Impressionists
Masterpieces of Art

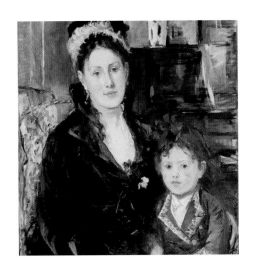

Publisher and Creative Director: Nick Wells
Commissioning Editor: Polly Prior
Senior Project Editor: Catherine Taylor
Picture Research: Catherine Taylor
Art Director: Mike Spender
Layout Design: Jane Ashley
Copy Editor: Anna Groves
Proofreader: Dawn Laker
Indexer: Helen Snaith

Special thanks to Amanda Justice and Lucy Engledow

FLAME TREE PUBLISHING
6 Melbray Mews
Fulham, London SW6 3NS
United Kingdom

www.flametreepublishing.com

First published 2017

17 19 21 20 18
1 3 5 7 9 10 8 6 4 2

Image Credits: Courtesy **akg-images:** 76. Courtesy **Artothek** / © Christie's Images Ltd: 90. Courtesy **Bridgeman Images** and the following: 1 & 108 Brooklyn Museum of Art, New York, USA / Museum Collection Fund; 3 & 79 Shelburne Museum, Vermont, USA / Gift of the Electra Havemeyer Webb Fund, Inc.; 4 & 110, 24 & 114, 63, 68, 112 National Gallery of Art, Washington DC, USA; 6bl & 30, 31, 50, 51, 66 National Gallery, London, UK; 6tr & 117, 54 The Art Institute of Chicago, IL, USA / Mr. and Mrs. Lewis Larned Coburn Memorial Collection; 7br & 48, 11 & 92, 12 & 43, 14 & 55, 15 & 104, 18 & 62, 22bl & 84, 23 & 107, 25br & 70, 40, 41, 44, 52, 60 & 98, 67, 71, 73, 74, 83, 85, 86, 115, 120, 122 Musee d'Orsay, Paris, France; 7tl & 36 Portland Art Museum, Oregon, USA; 8 & 106 Musee Fabre, Montpellier, France; 9 & 64, 19 & 34, 22tr & 91, 89, 118 Private Collection / Photo © Christie's Images; 10 & 69, 26 & 94, 87, 99, 111, 124 Musee Marmottan Monet, Paris, France; 12 & 56 & 128, 37 © Samuel Courtauld Trust, The Courtauld Gallery, London, UK; 13tl & 45 Musee des Beaux-Arts, Lyon, France; 13br & 53 Philadelphia Museum of Art, Pennsylvania, PA, USA / Bequest of Charlotte Dorrance Wright, 1978; 16 & 72, 20 & 102 & 113 Metropolitan Museum of Art, New York, USA; 17 & 33 Musee des Beaux-Arts, Tournai, Belgium; 21 & 80, 95 Musee des Beaux-Arts, Rouen, France; 25tl & 81, 39 State Hermitage Museum, St. Petersburg, Russia; 27 & 101 National Museum Wales; 32, 100 Pushkin Museum, Moscow, Russia; 38 The Art Institute of Chicago, IL, USA / Potter Palmer Collection; 42 Petit Palais, Geneva, Switzerland; 46 Fogg Art Museum, Harvard Art Museums, USA / Bequest from the Collection of Maurice Wertheim, Class 1906; 47 Burrell Collection, Glasgow, Scotland / © Culture and Sport Glasgow (Museums); 49, 88, 97 Private Collection; 57 The Phillips Collection, Washington, D.C., USA / Acquired 1923; 58 Philadelphia Museum of Art, Pennsylvania, PA, USA / The Mr and Mrs Carroll S. Tyson, Jr Collection, 1963; 59 Private Collection / Photo © Lefevre Fine Art Ltd., London; 75 © Scottish National Gallery, Edinburgh; 77 Musee de l'Orangerie, Paris, France; 78 De Agostini Picture Library; 82 Musee Picasso, Paris, France; 96 Fine Arts Museums of San Francisco, CA, USA; 105 Dallas Museum of Art, Texas, USA / The Wendy and Emery Reves Collection; 109 The Art Institute of Chicago, IL, USA / Mr. and Mrs. Martin A. Ryerson Collection; 116, 121 Sterling and Francine Clark Art Institute, Williamstown, Massachusetts, USA; 119 Minneapolis Institute of Arts, MN, USA / The John R. Van Derlip Fund.

ISBN 978-1-78664-175-5

Printed in China I Created, Developed & Produced in the United Kingdom

Impressionists
Masterpieces of Art

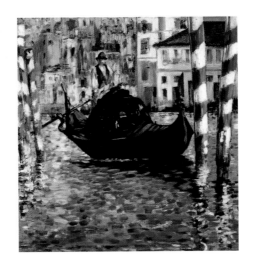

Michael Robinson

FLAME TREE
PUBLISHING

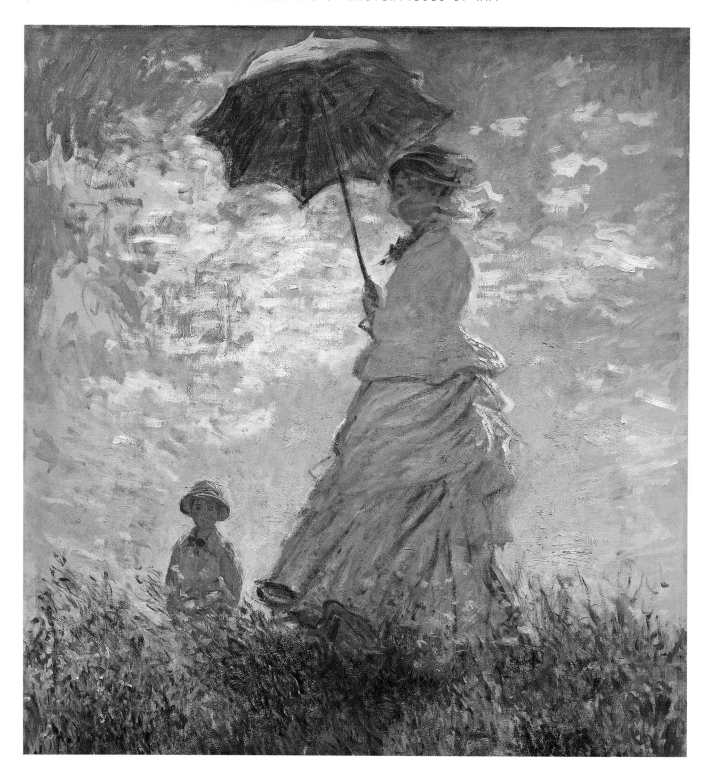

Contents

Impressionism: A Defining Movement

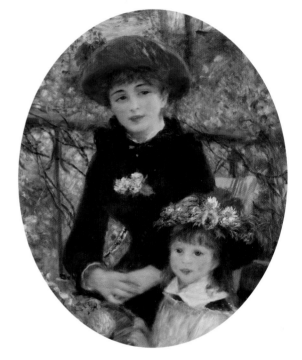

Since the late twentieth century, art historians have endlessly debated how we should define this term, originally used pejoratively by an art critic in 1874. If the Impressionists were characterized by the social group to which they belonged, that would include Édouard Manet, who refused to participate in any of their exhibitions, and exclude Berthe Morisot, who was effectively barred by a bourgeois sense of impropriety from associating with men in cafés. If Impressionism can be defined by its style or technique, then it would include artists such as Jean-Baptiste Camille Corot, whose paintings the writer Émile Zola referred to as 'Impressionism corrected'.

Despite the obvious aesthetic differences in the working practices of its main exponents, the consensus is that Impressionism as an artistic phenomenon could only have happened in Paris in the 1870s. This extraordinary set of circumstances resulted in an artistic canon that influenced the development of modern Western art.

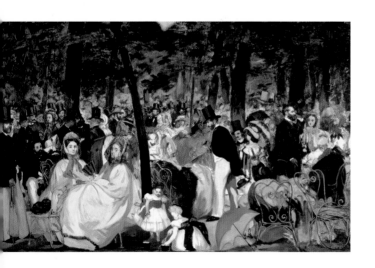

Historical Background

As early as 1846, the writer Charles Baudelaire (1821–67), writing a critique of that year's Salon exhibition, was urging artists to celebrate the 'heroism of modern life' instead of endlessly depicting the past. At that time, the Salon (of the Académie des Beaux-Arts) was the only public exhibition space in which artists could show their work. It was, like the Royal Academy in London, an ultra-conservative organization that only showed paintings it considered 'finished' to an academic standard and which closely adhered to the tenets of Neoclassicism. Jean-Baptiste Camille Corot (1796–1875) successfully blended Neoclassical principles with aspects of Realism. This he achieved through *en plein air* ('outdoor') painting of the French landscape, which was used earlier in the nineteenth century by the English artists John Constable (1776–1837) and J.M.W. Turner (1775–1851).

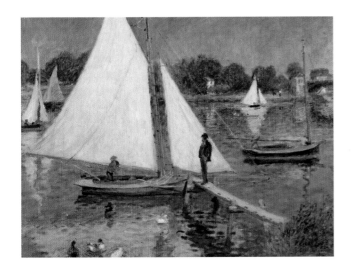

In 1845, Baudelaire proclaimed that Corot (himself an influence on Monet) was the leader of the modern school of landscape painting, but it was his later essay entitled 'The Painter of Modern Life', published in 1863, that was to inspire artists to embrace 'modernity'. Modernity to Baudelaire meant 'the ephemeral, the fugitive, the contingent, the half of art whose other half is the eternal and the immutable'. In essence, Baudelaire demanded artists depict those aspects of modern life that were transitory, while maintaining the principles of art – such as harmony and composition – that are immutable components of traditional art.

Between 1848 and 1870, France was ruled by Louis-Napoléon Bonaparte (1808–73), later Emperor Napoleon III, and it was in this period of the Second Empire that the modernization of Paris began. Beginning in 1853 and continuing for two decades, Paris saw the wholesale destruction of old buildings and narrow streets to make way for wide boulevards, shops, cafés and apartment blocks for the newly affluent bourgeoisie. Today's Paris is largely the work of Baron Haussmann (1809–91), the city's prefect who oversaw the imaginative transformation of a medieval city into a modern metropolis. Additionally, his designs were to incorporate the new railway termini, which provided transport to and from the city to the new suburbs, created as a result of the displacement of the old city's inhabitants. These same suburbs, mostly along the River Seine, such as Argenteuil, also provided leisure activities for the bourgeoisie to pursue at the weekends.

The impact of these changes on Parisian society is well documented by the artists of the time, who became known as the Impressionists. One of the earliest was Édouard Manet (1832–83), whose painting *Music in the Tuileries Gardens*, 1862 (see page 30) responds to Baudelaire's call to paint modern life. It has both the immutable aspects of a 'history' painting, in that it is indebted to Diego Velásquez (1599–1660) in its composition, but also the ephemeral nature that complies with modernity. It is the lack of traditional pictorial perspective and depth,

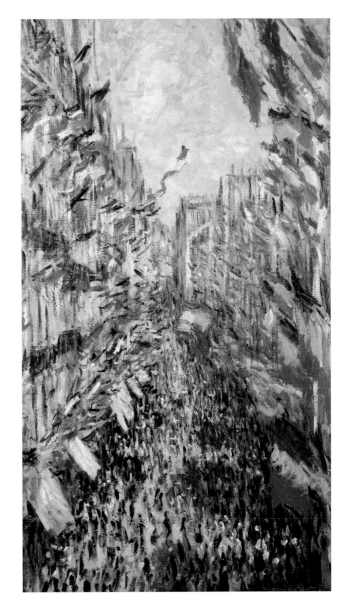

and, as Clement Greenberg aptly described the key characteristic of modern painting, an 'ineluctable flatness' of the painting's surface that defines it as 'modern'. Note also the fragment of a figure on the extreme left (the artist himself) that makes this composition ephemeral and the painting 'modern' in the Baudelairian sense.

The Impressionist Style

To respond to Baudelaire's ideas of modernity, it was necessary for artists to develop a new language in painting, pictorial forms that were inextricably linked to contemporary Paris and its development as a modern city. All of the artists, subsequently known as the Impressionists, had begun their careers in the 1860s with the aspiration of exhibiting their work at the official Salon, with varying degrees of success. An example of such success, exhibited at the Salon in 1868, was *Family Reunion* by Frédéric Bazille (1841–70).

During the 1860s, Manet was holding court at the Café Guerbois with a number of younger artists, including Claude Monet (1840–1926), Pierre-Auguste Renoir (1841–1919) and Camille Pissarro (1830–1903). Here, with writers such as Émile Zola (1840–1902), they discussed the modernity of their transformed city and its depiction. These artists and writers subsequently became known as the Batignolles Group, after the area in which the café was situated.

These artists developed a style that exhibited great bravura – boldness and brilliance – using painterly brushstrokes and a more pronounced use of colour. This proved anathema to the Salon jury, who rejected most of this work on the grounds that it was 'unfinished' and lacked the draughtsmanship found in academic painting. The group's florid palette and depictions of light were at odds with the sombre tones and use of chiaroscuro (strong contrasts of light and dark) found in the art of the past. Additionally, they began depicting the Paris of their own time, with its theatres, bars, restaurants and dance halls. The new railway system facilitated travel to the suburbs, where leisure opportunities presented themselves along the Seine. One such place was La Grenouillère (see page 31, *Bathers at La Grenouillère*). This was a popular weekend retreat near Argenteuil, where it was possible to swim and row pleasure boats along the river. This painting

is something of a departure for Monet and can be identified, along with Renoir's version of the same motif (see page 36, *The Seine at Argenteuil*), as the first truly Impressionist pictures. Here they use rapid brush marks with unnatural colour to highlight the dynamism of the scene, and the protagonists are indistinct and cannot be identified. It is an 'impression' of standing by the shoreline watching people enjoying themselves in the dappled sunlight of a weekend afternoon.

War and the Paris Commune

In July 1870, Napoleon III declared war on Prussia in an effort to suppress their larger European aspirations. The French were very quickly defeated in two main battles and by September the Prussians had reached the outskirts of Paris, laying siege to the city.

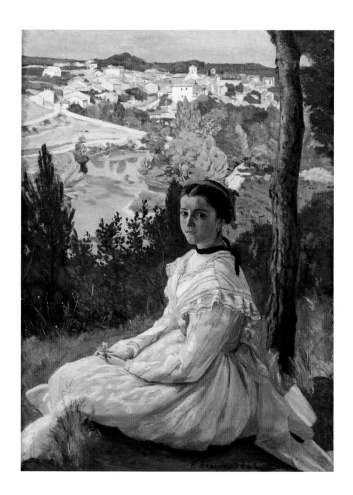

The siege lasted until January of 1871, when France surrendered following the loss of several thousand of its men. The defeat was humiliating for Paris, particularly since Prussian forces then occupied the city to suppress further insurrection. In turn, this led to civil war among the French, when the army was forced to intervene against a revolutionary government set up in the city, known as the Paris Commune. The civil war lasted just over two months and claimed many more thousands of French lives.

One of the casualties of the war was Bazille, who was killed in action in 1870; while both Monet and Pissarro moved to London to escape the troubles. Here they saw the work of J.M.W. Turner. His ethereal paintings were to influence Monet in particular. It was also where they met the art dealer Paul Durand-Ruel (1831–1922), who was to play a key role in their careers.

After the appalling events in Paris of 1870–71, the time was ripe for a more uplifting art, one that looked to the future, one that rejected the past and embraced colour to portray a sense of *joie de vivre*. Impressionism was born. It marked the beginning of a change of direction in painting that emphasized colour to express form and create mood, a change that was to precipitate the exploration of paint itself, for its own aesthetic qualities, by subsequent generations of artists.

Aftermath

Despite the ravages of war, Paris enjoyed a few years of financial prosperity, in what became the Third Republic. On his return from London, Durand-Ruel bought many paintings from the Impressionist painters, most notably Monet. In addition, a small number of new patrons emerged, eager to acquire this new exciting work, albeit on a speculative basis, including the wealthy department store owner Ernest Hoschedé (1837–91). The growth of these markets and the continued rejection by the Salon of this 'new' style of painting encouraged these artists to stage their own independent exhibition in 1874. This was to prove a spectacular failure for the Impressionists, due to the lambasting they received from the critics, compounded by the downturn in the French economy.

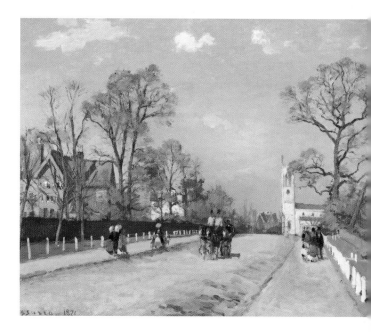

This mid-decade downturn meant Durand-Ruel was no longer able to buy the Impressionists' work and, worse still, Hoschedé was declared bankrupt. Not only was he unable to continue his patronage of these artists, most notably Monet, but he was also forced to sell his art collection at a fraction of its previous market value. For example, he bought *Impression: Sunrise* for 800 francs and sold it for 200. This depression of market values affected not only Monet's work but also that of others in the group, each of whom were struggling financially, a situation that continued into the following decade.

Paul Durand-Ruel

Durand-Ruel inherited his father's art-dealing business in 1865 and was already an established collector and dealer in the work of the Barbizon school of artists, which included Corot and Charles-François Daubigny (1817–78), both of whom are seen as the precursors of Impressionism. During the Franco-Prussian War, Durand-Ruel left Paris, opening a gallery in London to show the work of 'The Society of French Artists'. It was there that he met Monet and Pissarro. On returning to Paris, he began collecting and supporting the work of the Impressionists.

In all, Durand-Ruel bought over 5,000 Impressionist works, including in excess of 1,000 Monets and 1,500 Renoirs. The dealer was unusual in that he would buy a living artist's work directly from the studio, often several paintings at a time. By this method, he was not only supporting these young artists but also effectively cornering the market for their work. It was a risky strategy and one that took many years to show a good return. Surprisingly, there was a limited market for this innovative work in Paris, and in Europe generally, because of the continued domination of academic art.

In 1886, Durand-Ruel, exasperated and frustrated at this lack of enthusiasm for Impressionism, sent 300 pictures to the United States of America and arranged exhibitions in New York, Washington and Philadelphia, selling nearly 50 of his pictures at an inflated price. He famously remarked about his new market, 'America does not laugh, it buys'.

In his tribute to the dealer on his death in 1922, Monet remarked, 'We (the Impressionists) would have died of hunger without Durand-Ruel.'

The First Impressionist Exhibition

In December 1873, the Batignolles Group of artists, which included Monet, Renoir and Pissarro, registered itself as the Société Anonyme Coopérative des Artistes Peintres, Sculpteurs, Graveurs ('Co-operative and Anonymous Association of Painters, Sculptors and Engravers') to facilitate the exhibition of their work independent of the official Salon. Their ranks were joined by Alfred Sisley (1839–99), Edgar Degas (1834–1917), Armand Guillaumin (1841–1927), Paul Cézanne (1839–1906) and Berthe Morisot (1841–95).

Their first exhibition took place in April 1874 at the former studio of the society photographer Nadar (1820–1910), in the very fashionable Boulevard des Capucines. Noticeable by his absence was Manet, who, despite supporting their efforts, continued to seek recognition through the official Salon rather than the exhibitions organized by the group, a position he maintained for the rest of his career.

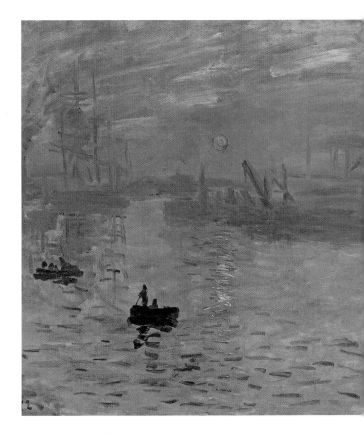

The critics were particularly scathing in their review of the exhibition. One of these, Louis Leroy, published an article in the satirical magazine *Le Charivari* entitled 'Exhibition of the Impressionists', in which he maligned most of the work, reserving his most scathing sarcasm for one of Monet's paintings, *Impression: Sunrise* (see page 69). Ironically it was Leroy's pejorative use of the term 'impression' that gave rise to the name by which these artists went at future exhibitions.

Subsequent Impressionist Exhibitions

The second exhibition was held in 1876 at Durand-Ruel's own gallery and the group was joined by Gustave Caillebotte (1848–94), who showed *The Floor Scrapers* (see page 41). Altogether, between 1874 and 1886, there were eight Impressionist exhibitions. Only Pissarro showed at all of them; others such as Renoir showed sporadically, while also trying to submit work to the Salon. In the fourth exhibition, in 1879, Mary Cassatt (1844–1926), an American émigré, began to

show her work, having been introduced to the group by Degas. Despite showing in all but one of the exhibitions, Degas refused to accept the tag 'Impressionist', referring to himself as a 'Realist' painter.

For the exhibition in 1879, Degas asserted his authority over the group and a more neutral title was chosen for the show – 'Exhibition of a Group of Independent Artists'. This exhibition was organized by Caillebotte, and most notable was the absence of Monet and Sisley. Although Renoir exhibited, both he and Monet also submitted work to the Salon, which angered Degas, accusing them of abandoning their artistic principles.

At the time of the fifth exhibition, in 1880, the only original members to still be showing work were Pissarro, Morisot and Degas. The others again submitted work to the Salon, which was applauded by the writer Zola, an original supporter of the Batignolles Group. Zola held Degas partly to blame for this fracture in the 'Impressionist' cause.

It was not until 1882 and the seventh exhibition that Monet, Renoir and Sisley returned to the fold. Ironically, it was the only exhibition to which Degas did not submit work. Apart from this absence, it was the most homogenous of all the so-called Impressionist exhibitions. The inclusion of *Luncheon of the Boating Party* marked the end of Renoir's Parisian studies, after which he would favour more Classical nudes; and Monet would embark on his 'series' paintings and move to Giverny.

In addition to Degas' scandalous nudes in the eighth and final Impressionist exhibition in 1886, another emerging artist, Georges Seurat (1859–91), exhibited a controversial picture, *La Grand Jatte*, which became a cause célèbre. The publication of an article by Félix Fénéon (1861–1944) entitled 'The Impressionists' actually spelt the death knell for Impressionism, by suggesting that it was on the wane and the 'Neo-Impressionism' of Seurat and another artist Paul Signac (1863–1935) was its successor.

Assenting Critical Voices

Not all critics were negative about Impressionism. Louis Duranty (1833–80), for example, published an article called 'La Nouvelle Peinture' in 1876, at the time of the second Impressionist exhibition, in which he was equally scathing about Salon art, suggesting that Impressionism was in effect a modern form of Realism. His approval,

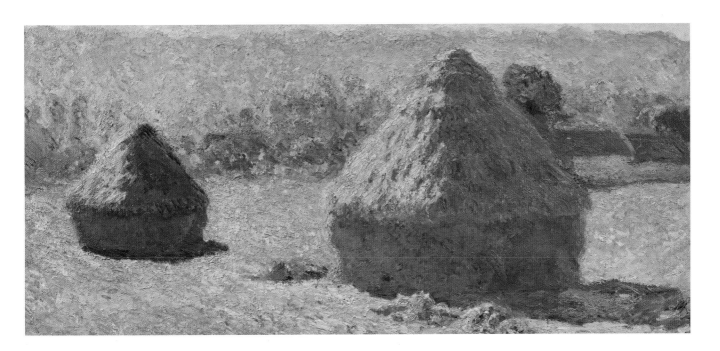

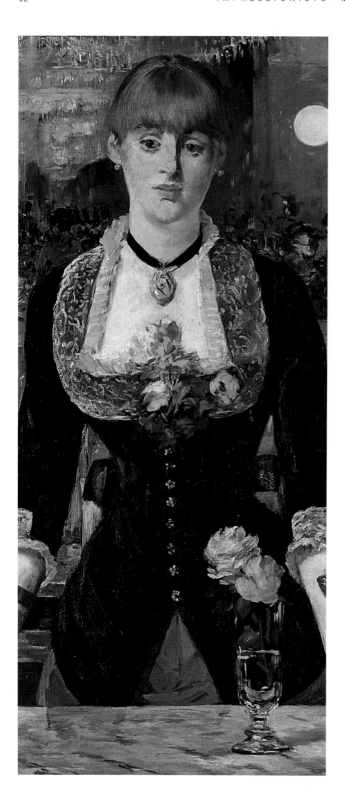

however, was aimed more specifically at Degas, who for him was the epitome of Baudelairian ideas in the depiction of a modern Paris. For Duranty, modernity was not the diffusive use of colour for effects (impressions), but rather a focus on the pictorial world that is not composed in a contrived manner.

In May 1878, Théodore Duret (1838–1927) published a pamphlet, 'Histoire des Peintres Impressionistes', which became the seminal work on this group of artists. Published to coincide with the fourth Impressionist exhibition, each chapter is devoted to the key members of the group, describing Renoir's women as 'enchantresses' and doubting that 'any painter has ever interpreted a woman in a more seductive way'. Duret is also credited with the use of the term 'avant-garde' as an artistic phenomenon.

Café Culture

Cafés and café-concerts developed with the modernization of Paris, so that by the end of the century Paris was seen as the entertainment capital of the world. Significantly, these venues were no longer the preserve of the idle rich, but were now accessible to the middle and lower classes as well. They were also well attended by tourists who came to Paris, to participate in an elegant urban culture, sophisticated but racy.

The café was the meeting place for all Parisian society, where strangers to the city could feel a part of Parisian life without actually participating in its discourse. This world was a male-dominated one, with women seen there as 'demimondaines' (women who belonged to the 'demimonde' were deemed to be of doubtful social standing and morality). In addition, Haussmann's wider boulevards thronging with cafés meant increased people-watching opportunities, very much the preserve of the *flâneur*. This 'gentleman stroller' was a key figure in nineteenth-century Parisian art and society, an anonymous observer of modern life, as advocated by Baudelaire.

Many of these cafés were also known as brasseries (a term derived from the serving of beer), an aspect that Manet in particular was keen to promote, as seen in his depiction of bottled beer

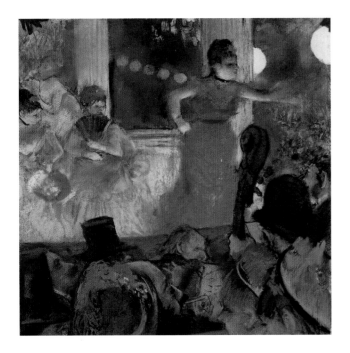

The Café-Concert

The café-concert was devised in the 1860s to provide entertainment for the café-going public. Many were indoors, but in the summer months the outside café-concert was very popular, often held in a marquee or awning attached to the main building. The café-concert had a vaudeville or music-hall atmosphere, with performances by singers, acrobats and comedians.

Until this time, theatres had a virtual monopoly on entertainment, since cafés did not have facilities found in theatres, such as costumes or props. At around this time, the government also lifted restrictions on the construction of new places of entertainment. By the early 1880s, the number of café-concert venues had increased nearly tenfold. The most notable of these were the Café des Ambassadeurs and the Café Morel, situated next door to each other on the Champs-Elysées, both drawing in middle- and upper-class clientele.

beside champagne in *A Bar at the Folies-Bergère* (see page 55). This symbolism demonstrates Manet's democratizing of urban entertainment for all, not just the privileged.

Degas demonstrates the darker side of café culture in the picture *L'Absinthe* (see page 40). Its melancholic mood refers to what the contemporary writer and sociologist Georg Simmel (1858–1918) referred to as the 'nearness and remoteness' of urban life. In this painting one can see the despair on the face and in the rounded shoulders of the woman, who has a glass of absinthe in front of her. Meanwhile the man sitting next to her is preoccupied and indifferent to her plight. They are alienated from each other and from society. Absinthe was originally a working-class drink, being relatively cheap due to its mass production and consumption, but became fashionable among the bourgeoisie. Following the Paris Commune there was a purge against heavy drinking among the working classes, who were blamed for the insurrection. The trouble-making Communards were often referred to as the 'apostles of absinthe'. Despite this, the bourgeoisie continued to drink this spirit and were immune from such persecution, a hypocrisy highlighted by Zola in his novel *L'Assommoir*.

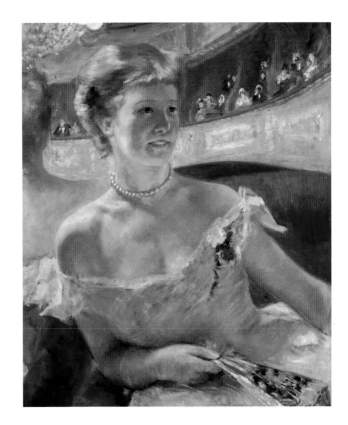

The entertainers, often working-class women or even demimondaines, were often lewd and bawdy in their entertainment, but overcame the strict censorship of the authorities by their use of double entendres. There was a wide variety of café-concert venues that appealed to a range of different classes in Parisian society. With one or two exceptions, most of the portrayals of the café-concerts were by Manet and Degas, the former concentrating on the audience and the latter on the performers (see pages 50, *Corner of a Café-Concert*, and 45, *Café-Concert at Les Ambassadeurs*).

Theatre and the Opera

At the first Impressionist exhibition of 1874, Renoir exhibited a painting called *The Theatre Box (La Loge)* (see page 37), seen by many as a masterpiece of Impressionism, not just in style but also as a 'modern' subject. The loge, or box, is a clever device for framing the subject, which for Renoir was the beautiful woman. Although voyeuristic to the sensibilities of our own time, it was customary for the woman to sit at the front of the loge, so that the male viewers in other parts of the theatre were able to admire her beauty, her male companion acting as a foil enhancing those qualities. No doubt her companion is admiring the women who decorate the front of the other loges.

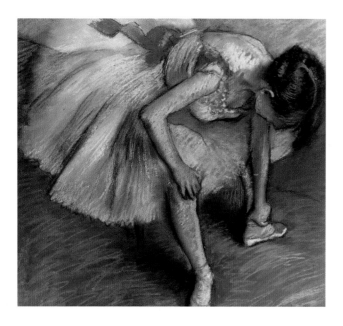

Another take on the same subject is by Cassatt in her *Woman with a Pearl Necklace in a Loge* (see page 53). Unlike Renoir's image of a lower middle-class woman called Nini, Cassatt portrays a woman of sophistication and class. More importantly, she is a self-assured and mature young woman, who does not need to hide behind her fan. She is also situated close to the stage in the more expensive lower-tier loges. Cassatt places a mirror behind the sitter to reflect the loges opposite, and also has the woman looking towards not the, it is assumed, male viewer, but at the stage itself.

The Ballet

In 1875, at the newly opened Palais Garnier theatre, ballet blossomed into a key feature of Parisian life. Degas began visiting the ballet to study the dancers in detail. He created a series of paintings and drawings of the ballet, in which he depicted the harsh realities of practice and fatigue in his dancers. Degas' haute-bourgeois class provided him with privileged access, enabling him to sketch dancers not just performing, but also in rehearsal and off-guard moments (see page 55, *Seated Dancer*). Degas also knew many of the leading dance masters of the age, such as Jules Perrot (1810–92). In *The Rehearsal* (see page 47), the viewer is invited into this intimate space to see the dance master M. Perrot in a red shirt, putting his dancers through their paces. The picture is divided into two separate areas, active in the top left and passive in the bottom right, a compositional ruse that emphasizes the modernity of the picture in terms of its structure as well as its subject matter.

The figure adjusting the dress of the standing dancer is Degas' housekeeper, but many of his other pictures of this type depict an intimacy between dancer and doting mother. These young women were often pushed to physical exhaustion by their dance masters and also by their mothers, eager to see their daughters' progress. Many would begin their ballet coaching at seven or eight years of age, with the ambition of passing examinations so that by about the age of ten they would qualify for a stipend. These girls often came from working-class backgrounds and the stipend would make a useful contribution to the family's income. Should she reach the position of a leading dancer within the ballet de corps, her stipend would in many cases

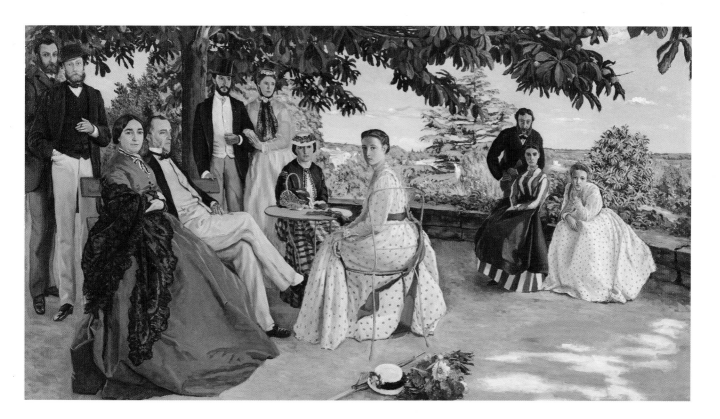

have exceeded that of the main breadwinner in the household, hence the reason for mothers being often present in Degas' pictures.

Social Gatherings

Renoir loved to show the *joie de vivre* of Parisian society, and began to attend the Sunday dances at the Moulin de la Galette in Montmartre. For his picture of one of these dances, *The Ball at the Moulin de la Galette* (see page 43), Renoir peopled the scene with his own friends and female models of his acquaintance: the two women in the foreground are sisters; the one standing also appears in Renoir's painting *The Swing* (see page 44); the woman in the pink dress dancing is another model he regularly used, called Margot; and Margot is accompanied by Don Pedro Vidal Solares, a painter from Cuba who was living in Paris at the time.

In terms of its Baudelarian ideal, it is a work of art that has all the immutable hallmarks of the academic painting of Jean-Antoine

Watteau (1684–1721), but it has the transience of modernity in its portrayal of fashion and the sensuousness of the dappled sunlight of a summer afternoon.

Domesticity

Apart from the two female artists, Mary Cassatt and Berthe Morisot, the only other artist to really engage with domesticity as a subject matter was Renoir. His *Young Girls at the Piano* (see page 123) is one example. Monet, in his early career, often depicted his own family, but following the death of his first wife Camille in 1879, his enthusiasm for the subject waned. Degas was never married and his intimate scenes are less about domestic life than voyeuristic indulgence, and contrast greatly with Cassatt and Morisot's approaches to the subject.

Morisot was married to Manet's bother Eugène (1833–92), with whom she had a child, as depicted in *The Artist's Daughter Julie with Her Nanny* (see page 119). In her depictions of women at their toilet,

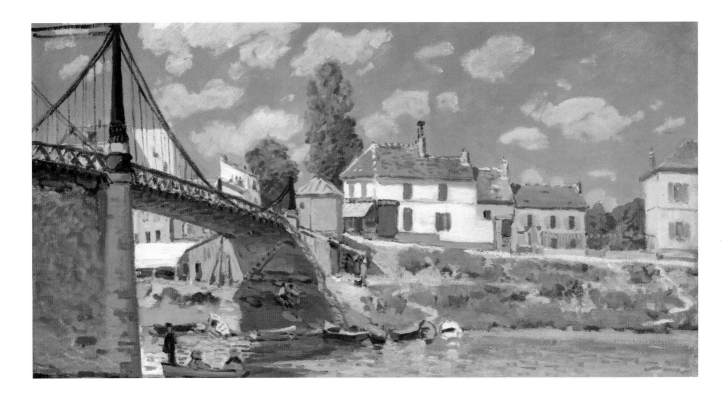

there is a feminine grace, elegance and lightness, as in *The Bath (Girl Arranging Her Hair)* (see page 121). It is interesting to compare this to similar subjects by Degas, as in *La Toilette (Woman Combing Her Hair)* (see page 122), which has an altogether more voyeuristic feel to it, enhanced by the darker tones.

It is also interesting to compare the domestic scenes of other families by Morisot and Renoir. Morisot's *Portrait of Madame Boursier and Her Daughter* (see page 108) and Renoir's *Madame Georges Charpentier and Her Children* (see page 113) share similar values of bourgeois family life in a relaxed, harmonious environment. Cassatt once wrote that she loved to paint children, because they are so natural and truthful without ulterior motive. This is evident in her paintings, for example in *Little Girl in a Blue Armchair* (see page 114).

The Landscape

In the years of the Second Empire (1851–70), before the Paris Commune, there was an ambiguity about landscape painting.

The government actively encouraged it, purchasing many such works from the Salon and displaying them in both urban and rural museums throughout France, in order to promote a sense of a diverse and yet unified country. The Académie des Beaux-Arts, however, did not see landscape painting as a serious art form, despite the Salon awarding medals to landscape artists such as Daubigny and Corot. In fact, no landscape artist was admitted to the Académie until 1890, when it was democratized.

Following the creation of the Third Republic in 1871, Charles Blanc (1813–82) was appointed as the director of the Académie. His agenda, politically motivated, was to promote art that had a public function. Despite the government still buying landscape works, their number was drastically reduced, and in 1877 it only purchased three landscape paintings. The type of landscape was also a consideration, with preference given to conventional scenes with an element of the sentimental picturesque. The lack of state patronage of landscape artists, which would have included Monet, Pissarro and Sisley, was exactly the opportunity Durand-Ruel was looking

for. At this time, he was already successfully showing and selling the work of the Barbizon school and was well aware of landscape painting's popularity among the art-buying public.

In an astute piece of marketing, Durand-Ruel published a series of catalogues under the title 'Galerie Durand-Ruel', in which he selected works from his own gallery to promote certain landscape artists. Using the skills of the writer Armand Silvestre (1837–1901), he demonstrated the lineage of high art, beginning with Eugène Delacroix (1798–1863) and tracing it through the Barbizon school and, of course, the Impressionist painters. Silvestre emphasized the modernity of the Impressionist painters' style as being an artist's personal response to the landscape, and that 'true art' belonged in the private sector, an obvious rebuttal of Blanc's agenda. The personal responses included the effects of the light on a motif rather than the motif itself, and the mood the scene evoked in the artist's mind. One of the prime examples is *Wild Poppies, Near Argenteuil* (see page 74)

Impressionism was a blatant challenge to the conventions of traditional landscape painting and critics were forced to find a new language to interpret this assault on the viewer's senses. What would have been striking, for example, in Sisley's *The Bridge at Villeneuve-la-Garenne* (see page 72) was the inclusion of modern houses, and the loose paint marks of the water and its reflections, both of which flouted the conventions of the previous generation's landscape painting.

Édouard Manet

Often regarded as the elder statesman of Impressionism, Manet refused to participate in any of their eight exhibitions, preferring instead to seek the artistic approval of the Salon. More accurately, Manet served as a conduit between Realism and Impressionism. His most celebrated works include *Le Déjeuner sur l'herbe* and *Olympia*, both of which were at the Salon des Refusés, having been rejected by the official Salon because of their scandalous subject matter. Both pictures caused a furore, making Manet one of the most talked-about artists in Paris. Manet then began to develop a more Impressionistic style, as demonstrated in his painting of *Argenteuil* (see page 33). More important was his leadership of the Batignolles Group at the Café Guerbois, in which the group discussed the depiction of modern Paris.

Manet was the son of a judge at the Palais de Justice, an important and influential figure in Paris. Édouard persuaded his father to allow him to pursue a career in painting and enrolled at the studio of the historical painter Thomas Couture (1815–79). Following his apprenticeship at Couture's studio, he set up his own studio in the Batignolles district of the city with his father's financial support. By 1861, he was beginning to send work on a regular basis to the official Salon. In 1862, Manet's father died, leaving Édouard and his brother Eugène a small fortune each, allowing them to become completely independent. That same year, Édouard painted one of his most famous pictures, *Music in the Tuileries Gardens* (see page 30), which was exhibited the following year at his first one-man exhibition, at the gallery of Louis Martinet (1814–95). The painting conformed to Baudelaire's ideal of the 'heroism of modern life' in its depiction of the artist and his friends at an open-air concert. It embraces the transitory nature of the modern, its fashions and the indistinct features of some of the protagonists, while at the same time showing the immutable qualities of older historical paintings, such as Velásquez's *The Little Cavaliers*.

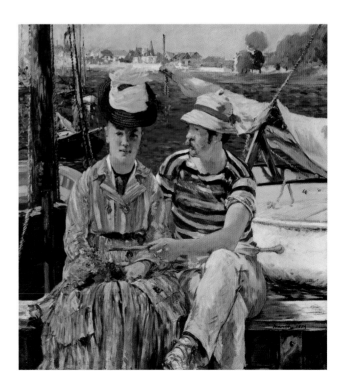

Throughout the 1860s, Manet continued submitting his paintings to the Salon with varying degrees of success, but in the following decade he developed an altogether lighter palette, having painted with both Monet and Renoir at Argenteuil. Monet lived there from 1871 to 1878, which was partially financed by Manet after the disastrous first Impressionist exhibition of 1874. Despite this friendship and association with these younger artists, Manet refused to exhibit with them, declaring, 'The Salon is the real battleground.'

Claude Monet

Monet was one of Manet's eager disciples, who in turn encouraged the older painter to lighten his palette, and develop a style of *en plein air* painting. He was born in Paris, but when he was only six years old, his family moved to Le Havre on the Normandy coast, where his father prospered financially. The coastline of northern France was to be a lasting influence as a motif for the artist. Despite not receiving the support of his family, Monet became a pupil at the Académie Suisse in 1859, where he met Pissarro, and then spent a few months at the studio of the artist Charles Gleyre (1806–74), where he met Renoir, Bazille and Sisley, who were also studying under him. An early influence on Monet was the artist Eugène Boudin (1824–98), whom he met and befriended in 1857. It was Boudin who encouraged him to paint landscapes and large skies *en plein air*, and also contributed a painting to the first Impressionist exhibition.

After leaving Gleyre's studio in 1863, Monet and his friends began painting *en plein air* at the forest of Fontainebleu, south of Paris, an area that had been made famous by the Barbizon school of painters that included Corot and Daubigny. In the following two years, Monet exhibited at the Salon with some success as a marine painter, and enjoyed the summers with his family at Sainte-Adresse on the Normandy coast, where he continued painting. Gardens, such as those he painted at Sainte-Adresse, continued to be a theme in much of Monet's work (see page 62, *Flowering Garden at Sainte-Adresse*). However, the artist had to keep his affair with Camille Doncieux, with whom he had a son, secret from his family in order that he continue to benefit from his father's financial support.

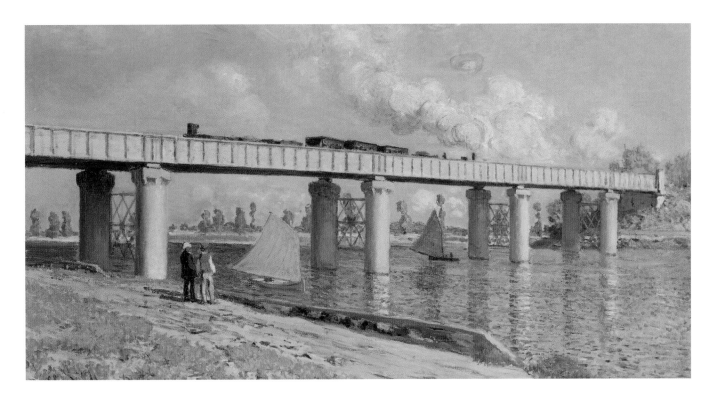

For much of his career, Monet lived in a state of penury and was frequently supported by patrons such as Hoschedé and the art dealer Durand-Ruel, both of whom purchased his paintings in the first half of the 1870s. Monet's financial fortunes changed with these regular purchases and a small inheritance he gained upon his father's death in 1871. He was able to live in a spacious house at Argenteuil, which provided endless motifs for his paintings. His father's death also meant that he no longer had to keep secret his relationship with Camille, whom he married in 1870.

However, following the bankruptcy of Hoschedé in 1877 and the death of Camille in 1879, leaving him as sole carer of his son, Monet was again in desperate financial difficulties and continued to be until the late 1880s, when his work began to sell to the American market. Despite Durand-Ruel's help in these lean years, Monet turned to Ruel's rival Georges Petit (1856–1920), who put on two exhibitions of the artist's work in 1885 and 1887, both of which were very successful. This led to Monet buying the house and garden in Giverny in 1890, where he remained for the rest of his

life and which provided the inspiration for almost all of his subsequent work.

Pierre-Auguste Renoir

Of all the Impressionist painters, Renoir's art is infused with the *joie de vivre* that he genuinely felt in life, despite its hardships and his physical condition. He was often ill and suffered from bouts of depression and chronic arthritis. He was born in Limoges as the son of a tailor, his family moving to Paris when he was three. With minimal education, he was apprenticed as a porcelain painter from 1854 to 1858, before enrolling firstly at the École des Beaux-Arts and then at the studio of Charles Gleyre, where he met Monet, Sisley and Bazille.

He had varying successes at the official Salon until 1869, when he began painting more experimentally with Monet on an almost daily basis at Bougival, a suburb of Paris. Similar pictures were produced by the artists of a weekend leisure venue on the Seine, an island known as La Grenouillère. However, the peace and tranquillity of this era was

shattered with the advent of the Franco-Prussian War, in which Renoir enlisted as a cavalryman and his close friend Bazille was killed.

In the following summers of 1872 and 1873, Renoir continued painting with Monet, this time at Argenteuil, where the latter had rented a house on his return from London. *The Seine at Argenteuil* (see page 36) is from this period. He also began to sell his work to Durand-Ruel, but with the French economy in decline, Renoir, like his friends, began to struggle financially.

For Renoir, the first Impressionist exhibition was not a total disaster, as he sold *The Theatre Box (La Loge)* (see page 37) for 425 francs, albeit after the exhibition. This was in spite of being castigated by the critics, who described his painting *The Dancer* as 'having legs as cottony as their gauze skirts'. Renoir hastily organized an auction of unsold work at the official auction house in Paris, the Hotel Druout, along with Monet, Sisley and Morisot. It was a very poor result for Renoir, selling 20 pictures at a little over 100 francs each.

His fortunes changed in 1875 and 1876 when he met some key patrons, who bought his work and also commissioned portraits from him. They

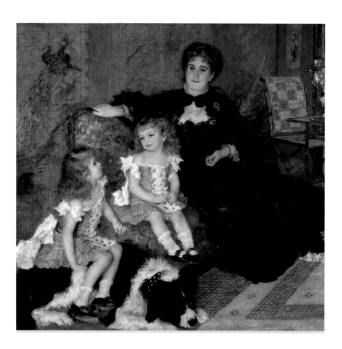

included the civil servant Victor Chocquet (1821–91) and the wealthy publisher Georges Charpentier (1846–1905). His spirits revived, he painted one of his most famous paintings, which encapsulates his spirit and that of those around him, *The Ball at the Moulin de la Galette* (see page 43). His portrait of Madame Charpentier (see page 113) was shown at the Salon in 1879 to good reviews and he was now beginning to tire of the rejection under the tag Impressionist.

In 1881, tired of Parisian life as an inspiration, he visited Algeria (then a French colony) before visiting Italy, looking closely at the Renaissance masters. Renoir participated at the seventh Impressionist exhibition in 1882 (having not shown there since 1877), and entered what became known as his 'dry period', when he had considerable doubts about his abilities as a painter. In essence, his time with Impressionism was over after declaring that he 'was at a dead end'. At this point, his style changed, embracing the art of the past in a new style that combined Impressionism with Classical forms. An example of this is his work *The Large Bathers* of 1884–87 (see page 58).

Alfred Sisley

Sisley was in several ways quite different from his fellow Impressionists. Although he was born in Paris, his parents were English, his father a successful businessman and his mother a sophisticated socialite. It was always assumed that the young Alfred would go into business like his father, and to that end he was sent to England in 1857 to study its practices. Although he spent the next four years there, he was more interested in visiting museums and galleries, where he would study the landscape paintings of Constable, Turner and the Anglo-French artist Richard Parkes Bonington (1802–28).

Returning to Paris, and with the financial support of his father, Sisley enrolled at the studio of Charles Gleyre, where he met Bazille, Renoir and Monet, the four of them spending time thereafter at Fountainebleu, the spiritual home of the Barbizon school. Sisley's earlier work shows Corot's influence in the use of intense greens, but by 1870 his palette had lightened, as shown in his painting *The Rest by the Stream, Edge of the Wood*, painted in 1872 (see page 71). At this time, there is an aesthetic unity in the work of the four artists from Gleyre's studio.

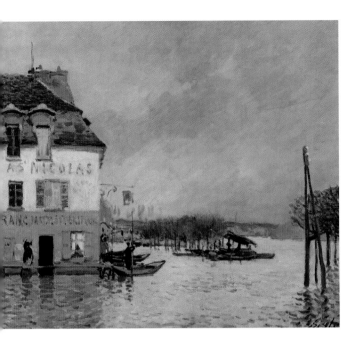

capture the essence of a modern city at all levels of society, in true Baudelairian spirit. Like Manet, Degas can be seen as the archetypal *flâneur*, the gentleman stroller of city streets, an anonymous man of the crowd, who revels in this 'immense reservoir of electrical energy', as Baudelaire famously put it.

Born into a wealthy banking family, his father encouraged him to paint, in particular portraits, since they had commercial potential. He set up his own studio at the family home under the tutelage of the academic artist Félix-Joseph Barrias (1822–1907) and regularly visited the Louvre copying the Old Masters and French artists such as Delacroix. Degas began painting historical narratives for exhibition at the Salon, while continuing with portraiture, and and although some of these paintings were exhibited at the salon, they afforded him no recognition.

It was, however, his role as *flâneur* that determined his artistic subjects. Two of his most important paintings of the 1870s were *L'Absinthe* (see page 40) and *Place de la Concorde* (see page 39). The latter picture very much sums up the role of the *flâneur* seeking out the transience of modern life and recording it for posterity.

Unlike his Impressionist contemporaries, Degas did not paint *en plein air,* but made reference sketches to be used for paintings executed in his studio. His subject matter too was at odds with most of the group. Unlike Monet or Sisley, he was not interested in capturing the fleeting transience of light in a landscape. His subject matter was urban life and, despite the bold, confident strokes used and the immediacy of the effect, his paintings were well planned and executed indoors. He also explored a number of different techniques of painting, such as pastel on paper as well as paint on canvas.

Following the unsuccessful first Impressionist exhibition, in which he participated, Degas established a good working relationship with Durand-Ruel, who actively promoted and sold his pictures of the ballet. Apart from depicting entertainment in Paris, Degas was also interested in other aspects of Parisian life, not least of which were ordinary working-class women at work. See, for example, *The Laundresses* (see page 120).

Following the demise of the family business and the premature death of his father in 1871, Sisley lost his financial support and he spent the rest of his life struggling financially. Sisley's art was modest, choosing to depict the landscape and the transitory effects of light, the shimmering of reflections on the water, whether it was a peacefully meandering river or the flood waters at Port-Marly, where he lived (see page 80, *The Flood at Port-Marly*). Unlike his fellow Impressionists, who all deviated from the aesthetic in one way or another, Sisley remained loyal to Impressionism both in practice and spirit. An example can be found in his *Church in Moret, Frosty Weather* (see page 95), in which the gentle softness of the shadow is in contrast to the deep shadows used by some of his fellow artists.

Edgar Degas

Although Degas participated in all but one of the Impressionist exhibitions, he cannot easily be placed in the Impressionist canon, rather like Manet. Instead he should be seen as one of the founders of a modernist tradition that bridged the gap between the conventions of the Salon and the new mode of painting that became Impressionism. He actually despised the term Impressionism due to its negative origins, and saw himself as a 'Realist' painter, seeking to

Camille Pissarro

The oldest of the Impressionist painters, Pissarro was born in the West Indies and spent much of his early life there, apart from attending school in France. He began his artistic training in Paris in 1855, and by 1859 had submitted his first painting to the Salon. He became a regular exhibitor at the Salon from 1859 to 1870, his style based on that of the Barbizon school, particularly Daubigny. His self-imposed exile in England during the Franco-Prussian War encouraged him to lighten his palette under the influence of his voluntary co-exile Monet. An example can be seen in *The Avenue, Sydenham* (see page 64). While in London, Pissarro married Julie Vellay (1838–1926), with whom he had seven children, his eldest son Lucien also becoming a well-known painter.

Returning to Paris in 1871, he first lived in the suburbs of Paris, Louveciennes and then Pontoise, where he painted the local landscape (see page 84, *Vegetable Garden with Trees in Blossom, Spring, Pontoise*), often in the company of Cézanne and Guillaumin. In 1874, he contributed to the first Impressionist exhibition and was the only member of the group to exhibit at all subsequent shows.

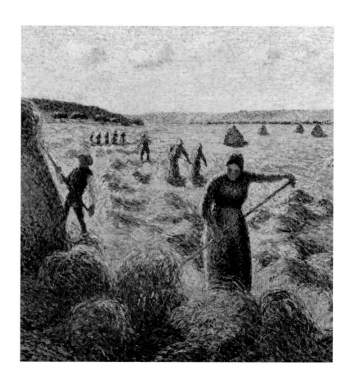

Pissarro continued working in his familiar Impressionist style until 1884, when he bought a house at Éragny-sur-Epte, about 80 kilometres north-west of Paris. The house contained an orchard that became a motif for his paintings, along with other images of rural peasants at work in the fields. It was at this time that he met the Neo-Impressionist artists Paul Signac and Georges Seurat, from whom he learnt a pointillist technique of painting based on a scientific approach to colour rendition and juxtaposition. *Harvesting Hay, Éragny* (see page 91) is a prime example that effectively combines Impressionism with this new style.

In the final decade of his life, Pissarro painted views of city streets in Paris, Rouen and Dieppe from a high vantage point, usually a hotel, an example being *Boulevard Montmartre* (see page 59).

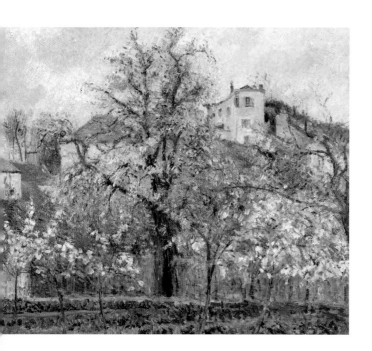

Berthe Morisot

As daughters of an haute-bourgeois family, the Morisot sisters received lessons in painting and drawing as part of their education, although it was only Berthe who pursued a career. By the age of

23 she had already been accepted as an exhibitor at the Salon and continued to submit work there until 1873. The work was mostly landscapes, directly influenced by Corot, who encouraged her to paint *en plein air*.

In 1868, she befriended Manet, who painted several portraits of her, and in 1874 married his brother Eugène, who was also an artist. Moving within that circle, although specifically precluded from the café environment because of the social propriety of the time, she became interested in the depiction of modern Parisian life, although more often within the domestic sphere (see *The Cradle*, page 107), using soft Impressionist colours in place of the darker, more sombre tones of the Realism of her earlier work.

It would be a mistake to imagine, however, that Morisot was not involved in 'the painting of modern life', since the depiction of fashion as a symbol of the modern is a principal Baudelairian ideal. However, Morisot does not commodify either the sitter or her fashion in these pictures (see for example page 51, *Summer Day*), unlike her male counterparts.

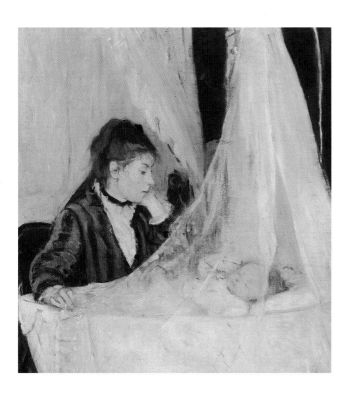

These soft domestic pictures had an instant appeal and in 1872 Durand-Ruel purchased 22 of them. Morisot contributed to the first Impressionist exhibition, showing 12 works, and exhibited at six of the remaining seven, being very loyal to the group and the Impressionist style.

Gustave Caillebotte

The youngest of the Impressionist group, Caillebotte was probably also the wealthiest, having been born into an upper-class Parisian family in 1848. His father was the owner of a military textile business. Caillebotte took a law degree and became eligible to practise in 1870.

Virtually self-taught, he began painting scenes of modern Paris after visiting the studio of the academic artist Léon Bonnat (1833–1922). Following his demobilization from the National Guard at the end of the Franco-Prussian War, Caillebotte began to take his painting more seriously. He inherited a fortune following his father's death in 1874, which enabled him to paint without any pressure to sell his work and he participated at the second Impressionist exhibition in 1876, exhibiting *The Floor Scrapers* (see page 41).

His style is more akin to that of Manet and Degas, in terms of his portrayal of modern Paris and its society, but he is remembered more for his financial support of the Impressionist artists, particularly Monet, than as a painter. However, recent scholarship has put considerable value on his work.

On his death in 1894, at the age of only 45, Caillebotte bequeathed his large collection of paintings that included 14 Monets and 19 Pissarros to the state, providing that they were displayed together at the Luxembourg Palace in Paris. Unfortunately, the French government refused the offer, due to the adverse publicity the Impressionists had received in the preceding years, and it took the considerable persuasive powers of the will's executor, Renoir, to negotiate an acceptable compromise. The government accepted 38 of the 67 paintings, refusing the others even when they were offered twice more by Renoir.

Mary Cassatt

Originally from Pennsylvania, Cassatt travelled extensively through Europe with her upper-class family between 1850 and 1855, as part of her early education. After 1865, she was back in Paris studying art under various academic painters, including Jean-Léon Gérôme (1824– 1904) and Manet's tutor Thomas Couture. She submitted work to the Salon with varying degrees of success, and following further European travel, she eventually settled in Paris in 1875 to begin her career as a 'painter of modern women' (see page 53, *Woman with a Pearl Necklace in a Loge*).

In 1877, Degas visited her studio and declared that 'here is someone who thinks as I do'. Cassatt is often depicted as Degas' pupil, but in fact they were kindred spirits willing to learn from each other. As a painter of Parisian women, Degas was, of course, interested in fashion, and to facilitate this interest he would often shop with her, for example, visiting millinery shops together. In fact, on some occasions, Cassatt actually posed for Degas, trying the hats on. Both artists eschewed the tag of Impressionism in favour of Realism.

Paul Cézanne

In Roger Fry's exhibition in London in 1910, 'Manet and the Post Impressionists', Cézanne was labelled as a Post Impressionist, along with Vincent van Gogh (1853–90), in order to separate his art from the work of the Impressionists. Subsequent to that event, Cézanne has been labelled as the 'father of modern painting'. However, this ignores the considerable achievements of his earlier Impressionist work. He submitted work to the first and third Impressionist exhibitions, but opted out of other shows.

Having moved to Paris in 1861, he met Pissarro who took him under his wing, encouraging him to lighten his palette. By the 1870s, they were painting together in Auvers and Pontoise, with an equal respect

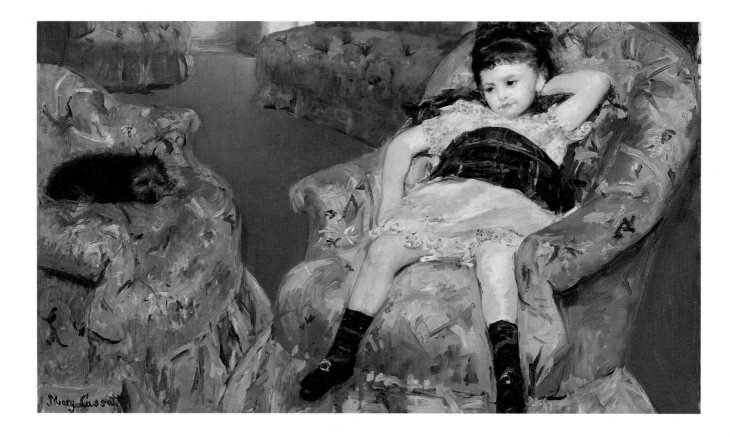

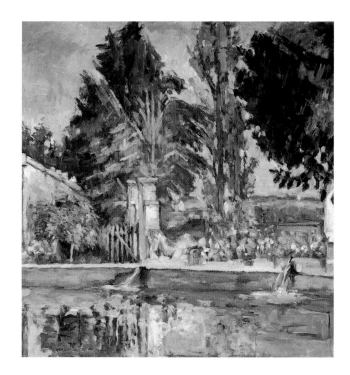

for each other. In 1880, Cézanne decided on an artistic exile away from other painters in the solitude of a house in Aix-en-Provence, from where he originated. He returned to the family home, where his father had a studio built for him (see *Jas de Bouffan, the Pool*, page 81).

In later years, a few individual paintings were shown at various venues, but then in 1895, a Parisian dealer, Ambroise Vollard (1866–1939), gave the artist his first solo exhibition and continued to promote his work exclusively.

Armand Guillaumin

In order to finance his art education and his early career, Guillaumin worked on the railways until 1866. After that, he still needed to take part-time jobs in order to sustain a living in the early days, working, for example, with Pissarro painting blinds, retaining a lifelong friendship with him, as well as with Cézanne.

Guillaumin participated in the first and several of the subsequent Impressionist exhibitions, and it was his handling of colour that brought

him to the attention of younger artists such as Signac and Van Gogh. It is easy to see how Guillaumin might have influenced the latter in the painting *Sunset at Ivry* (see page 70).

Following a win on the state lottery of 100,000 francs in 1891, Guillaumin spent the rest of his life painting without having to worry about sales. Nevertheless, the art dealer Ambroise Vollard and the Bernheim-Jeune gallery began to show his work. He spent the winters at Trayas and Agay, where he painted *The Coast from L'Esterel* (see page 97). In much of his late work, one can detect aspects of Fauvism, as practised by Henri Matisse (1869–1954) and Georges Braque (1882–1963) in their early careers.

The Crisis in Impressionism

By the early 1880s, there appeared to be a crisis about the future and direction of Impressionism. Degas and Cassatt never saw themselves as Impressionists but as Realists, using the exhibitions merely as a forum for displaying their paintings. By 1883, Manet had

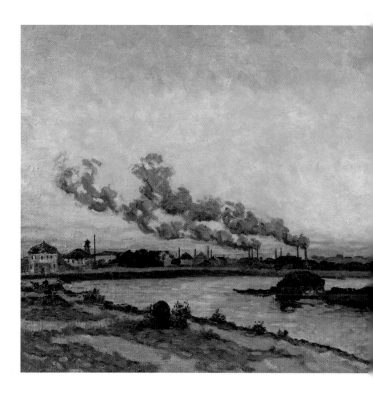

died, his last great picture, *A Bar at the Folies-Bergère*, exhibited at the Salon. Renoir moved away from pure Impressionism and developed more solidity to his figures, redolent of the Baroque style of Peter Paul Rubens (1577–1640). See, for example, his painting *Blonde Bather*, 1881 (see page 116).

Monet began to use a format of close proximity in his landscapes, repeatedly painting the same view to demonstrate the changing effects of light during the day on the same motif (see page 94,

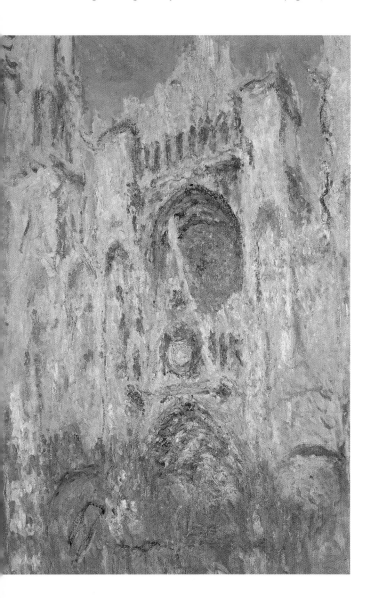

Rouen Cathedral, Effects of Sunlight, Sunset). This format reached its apogee in his Waterlilies series of paintings (see page 99). Pissarro came under the influence of the Neo-Impressionists such as Signac, but never fully developed their pointillist style of painting. Cassatt moved away from Impressionism and developed a style based very much on Japonisme, a fad that became popular with artists in the last quarter of the nineteenth century, in which Japanese culture and style were assimilated into a modern aesthetic.

Of the main Impressionists, only Morisot and Sisley remained true to the spirit of Impressionism and never wavered from its core principles.

Impressionism Elsewhere

It is possible to trace proto-Impressionism in England and Holland especially, as well as in France. However, Impressionism was a particular artistic phenomenon that occurred in Paris in the last quarter of the nineteenth century, and spread its influence in a cross-fertilization of ideas across the European continent and eventually to the United States, its aesthetic being eagerly taken up by artists there seeking something new.

In Britain, for example, one of the earliest advocates of Impressionism was the artist Philip Wilson Steer (1860–1942), a founding member of the New English Art Club, founded in 1886, which sought to challenge the Royal Academy by establishing its own exhibiting criteria. Other enthusiastic Impressionist painters, such as Walter Sickert (1860–1942), who was a close friend of Degas, and Pissarro's eldest son Lucien (1863–1944), who lived in London permanently from 1890, later joined the New English Art Club. Later artists such as Alfred Munnings (1878–1959) and Laura Knight (1877–1970) adopted the style and even made it acceptable to the very conservative Royal Academy in the 1920s.

The artist and writer Wynford Dewhurst (1864–1941) spent some time in Paris painting under the guidance and mentorship of Monet, to whom he dedicated his book *Impressionist Painting: Its*

genesis and development, published in 1904, the first major study of the subject in English. In this work, Dewhurst establishes the Impressionists' debt to the English painters Constable and Turner.

The Legacy of Impressionism

Impressionism was the first aesthetically avant-garde art movement because it broke the conventions of an accepted Realist art as prescribed by 'the Beaux-Arts system' and loosened that system's stranglehold on painting. Its successor, the so-called Post-Impressionism of Van Gogh, Seurat and Cézanne, would not have been possible without Impressionism's move towards a new language of painting. It would be equally hard to imagine the luscious paintings of the twentieth-century artists, such as Henri Matisse and Mark Rothko (1903–70), without the innovations of Impressionism.

Today, judging by the huge numbers attending the blockbuster exhibitions of the Impressionists' work, we are still fascinated and excited by their use of colour. We still adore the landscapes of Monet and Sisley, Pissarro's townscapes, and the delicate, intimate portraits by Renoir and Morisot. We are equally enthralled by the voyeuristic depictions of the demimonde by Degas and Manet.

This book is a celebration of the work of those artists whose names are now legendary. It is also a reminder of a time when painting ruled the visual arts. Our passion for these artists and their paintings remains, well over 100 years since they were first derided.

Modern Life & Leisure

Paris in the late nineteenth century was a centre of entertainment and excitement like no other European city at the time. The scenes and the joie de vivre experienced then were captured for posterity by the Impressionist artists.

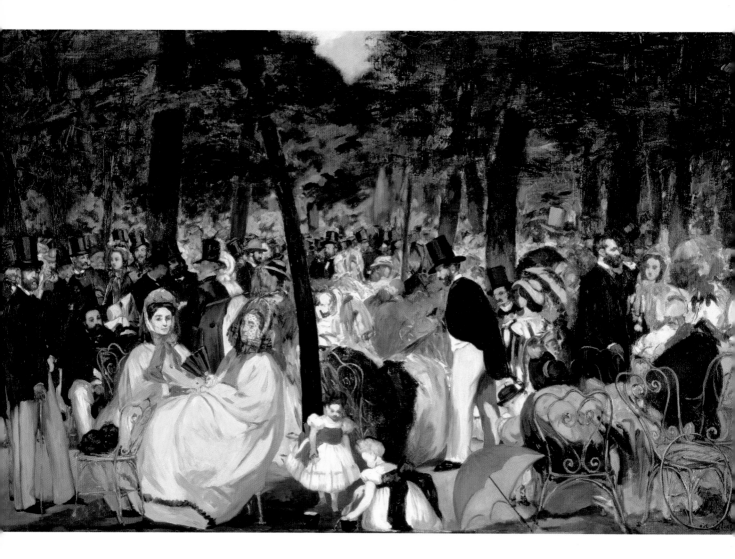

Édouard Manet (1832–83)
Oil on canvas, 76.2 x 118.1 cm (30 x 46²/s in) • The National Gallery, London

Music in the Tuileries Gardens, 1862 This painting is often regarded as the first 'modernist' work of art, by virtue of the frankness with which Manet declared the flat surfaces on which it was painted, and the indistinctness of some of the protagonists.

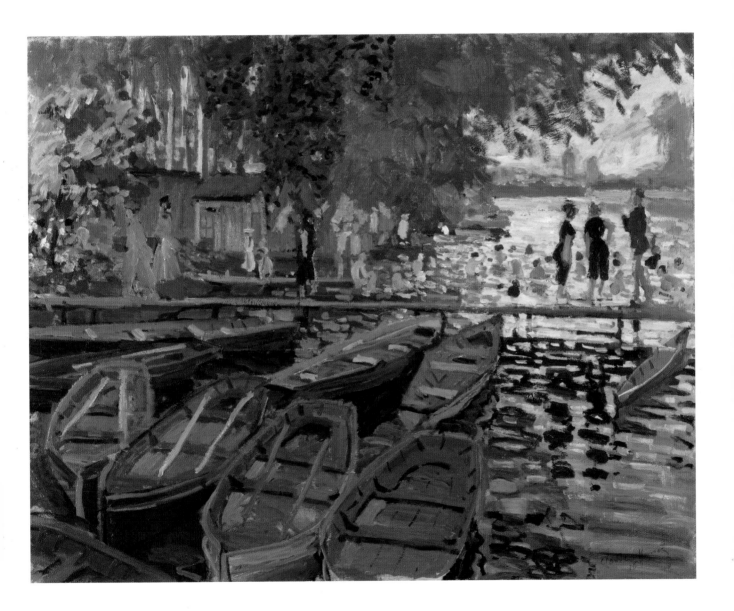

Claude Monet (1840–1926)
Oil on canvas, 73 x 92 cm (28³/₄ x 36¹/₄ in) • The National Gallery, London

Bathers at La Grenouillère, 1869 A pivotal work in the development of Impressionism, this is one of several paintings Monet executed at this location in the summer of 1869, when he was working *en plein air* with Renoir.

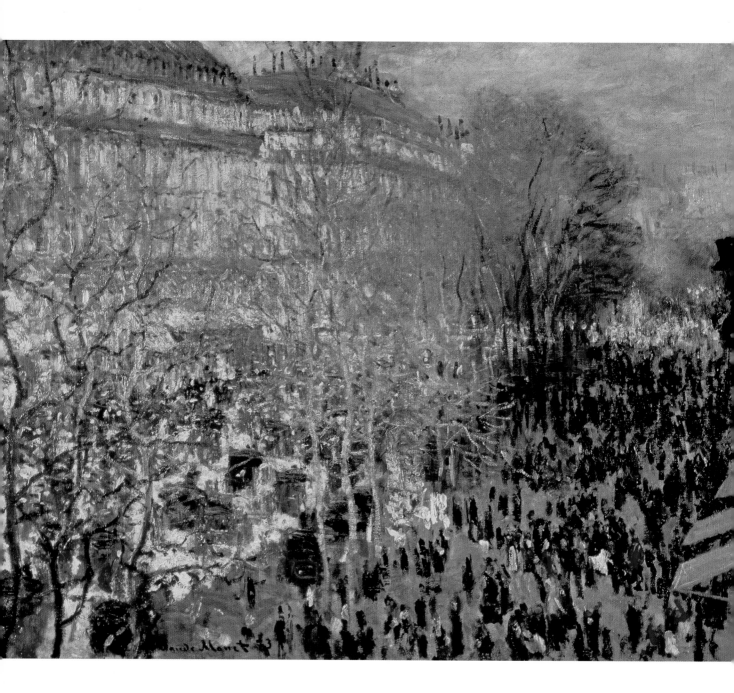

Claude Monet (1840–1926)
Oil on canvas, 61 x 80 cm (24 x 31²/₅ in) • Pushkin Museum, New York

Boulevard des Capucines, 1873 An opportunistic painting intended to appeal to the visitors at the first Impressionist exhibition held in 1874 at the former studios of the photographer Nadar, who was the first photographer to capture aerial views.

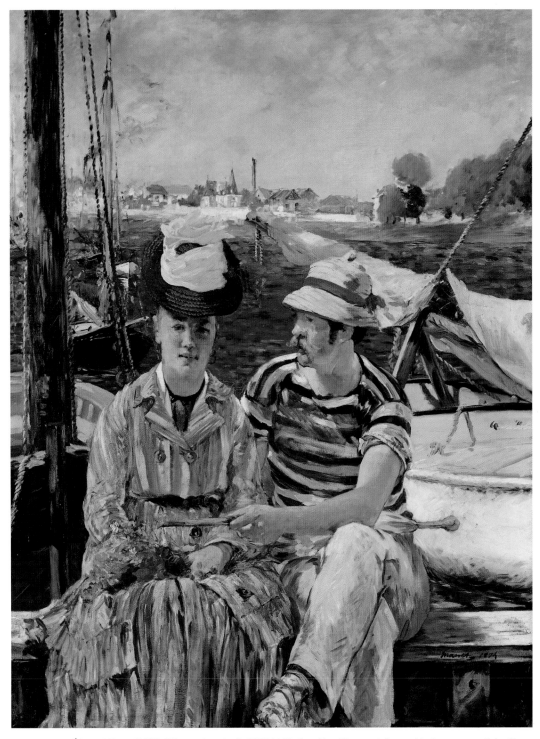

Édouard Manet (1832–83)
Oil on canvas, 149 x 115 cm (58²/₃ x 45¹/₃ in)
• Musée des Beaux-Arts, Tournai

Argenteuil, 1874 At this time, Manet became influenced by the younger artists with whom he associated, particularly Monet, and adopted a looser, more bravura style of painting. This work was shown at the Salon in 1875 and derided by the critics.

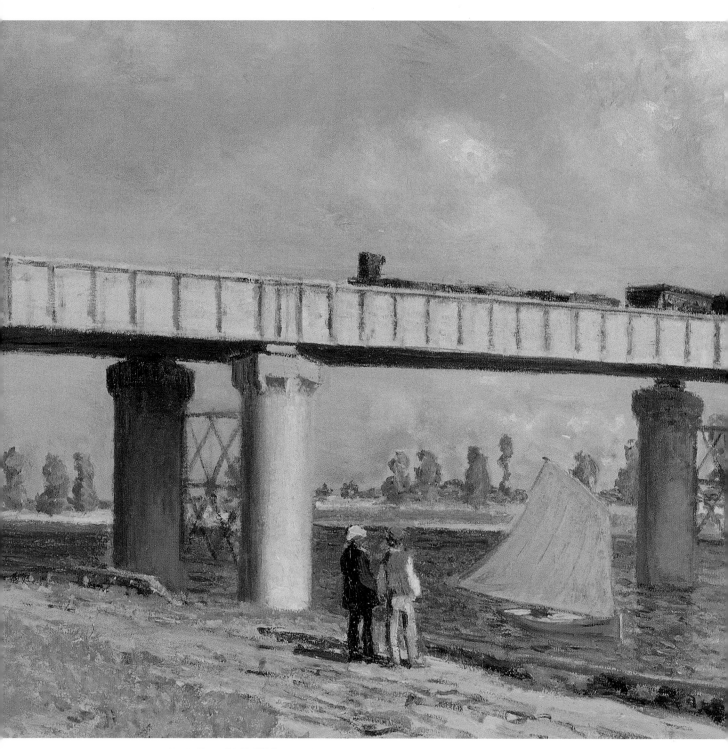

Claude Monet (1840–1926)
Oil on canvas, 60 x 98 cm (23²/₃ x 38²/₃ in) • Private Collection

Railway Bridge at Argenteuil, 1873 A painting that embraces the modern aspects of a rural landscape, with its modern steel bridge carrying a railway locomotive under full steam, cutting diagonally across the leisurely pursuits of the boats below.

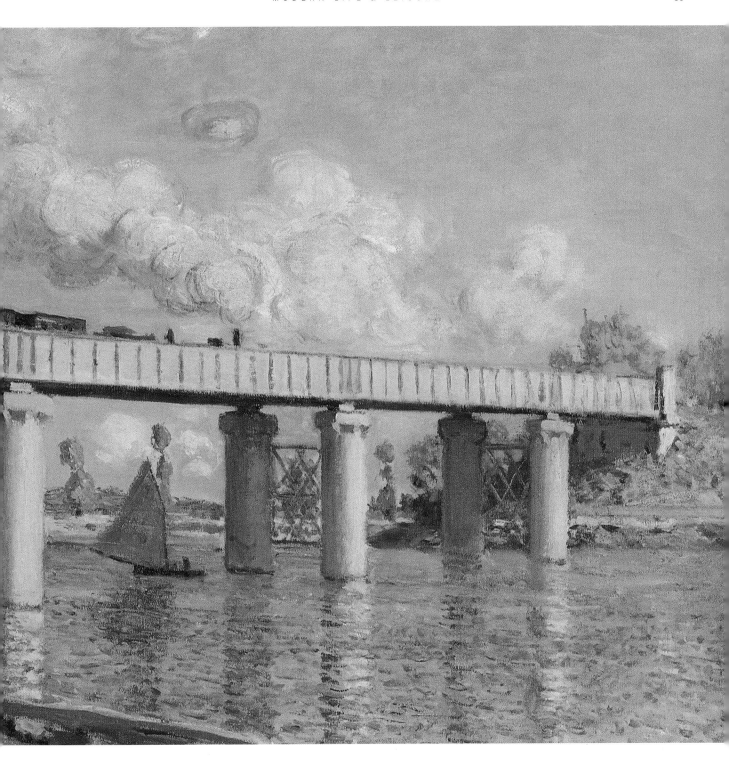

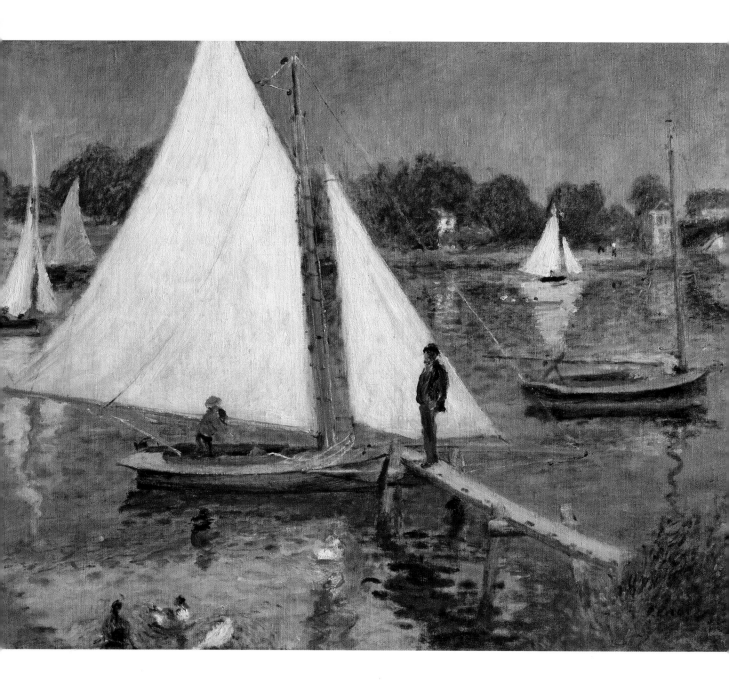

Pierre-Auguste Renoir (1841–1919)
Oil on canvas, 51 x 65 cm (20 x 25½ in) • Portland Art Museum, Oregon

The Seine at Argenteuil, 1874 This picture was painted sitting alongside Monet, who painted a similar scene called *Sailboats at Argenteuil*. Although primarily known as a portrait painter, Renoir showed his accomplished hand at landscapes too.

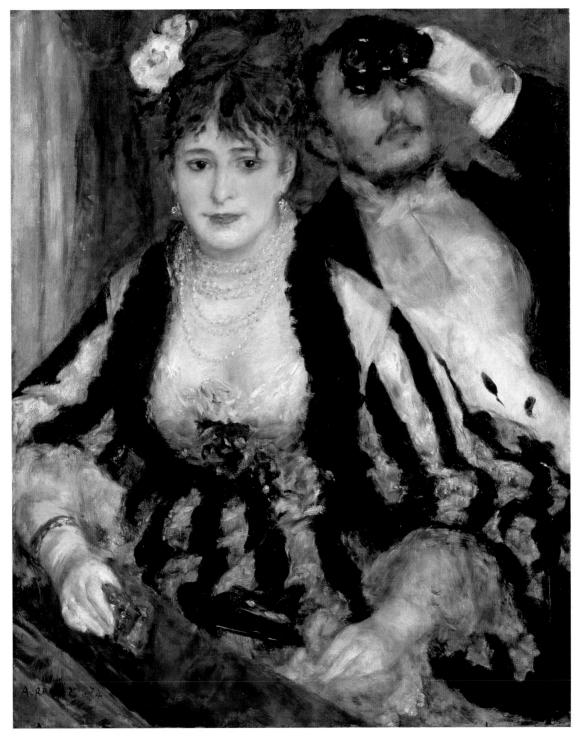

Pierre-Auguste Renoir (1841-1919)
Oil on canvas, 80 x 63 cm (31²/₅ x 24⁴/₅ in)
• The Courtauld Gallery, London

The Theatre Box (La Loge), 1874 The models for the painting were Renoir's brother, Edmond, and a young model, Nini. The heavy use of black is unusual in Impressionism, and acts as a foil to the other, more delicate colours in the painting.

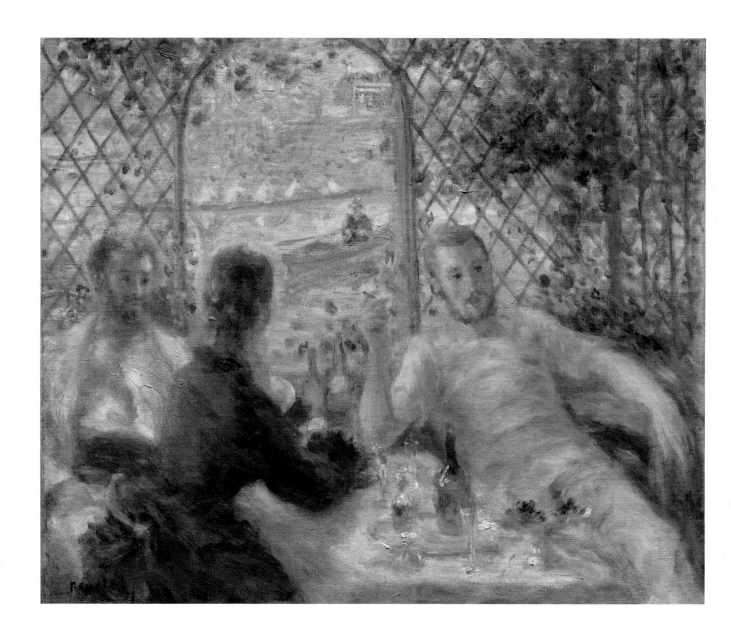

Pierre-Auguste Renoir (1841–1919)
Oil on canvas, 55 x 66 cm (21²/₃ x 26 in) • The Art Institute of Chicago

Lunch at the Restaurant Fournaise (The Rowers' Lunch), 1875 Exhibited at the second Impressionist exhibition in 1876, the painting depicts a group enjoying lunch by the River Seine at Chatou, just outside Paris. The venue is the same used in the later painting, *Luncheon of the Boating Party* (see page 57), executed in 1880–81.

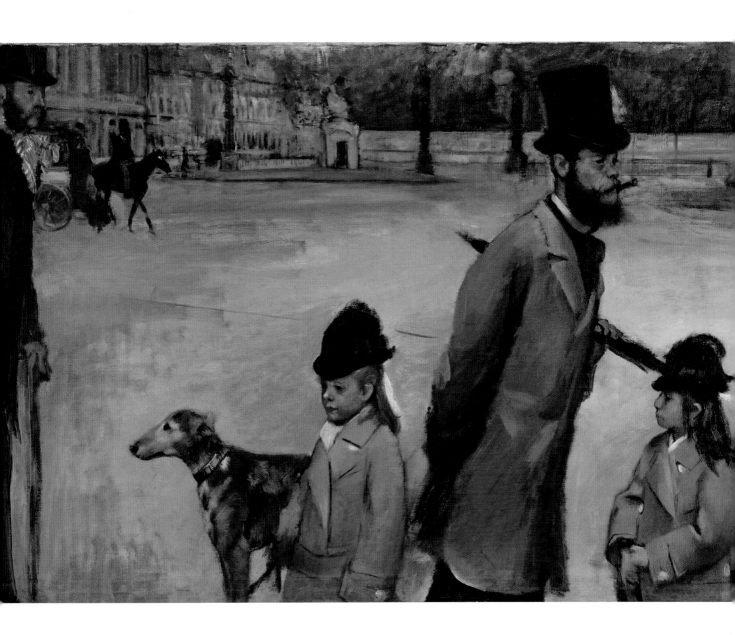

Edgar Degas (1834–1917)
Oil on canvas, 78.4 x 117.5 cm (31 × 46⅓ in)
• State Hermitage Museum, St Petersburg

Place de la Concorde, 1875 Baron Lepic (1839–89) is purposefully striding across the Place de la Concorde with his two daughters and dog, completely indifferent to all around him. The emptiness of the square behind adds to the sense that this is a transient moment.

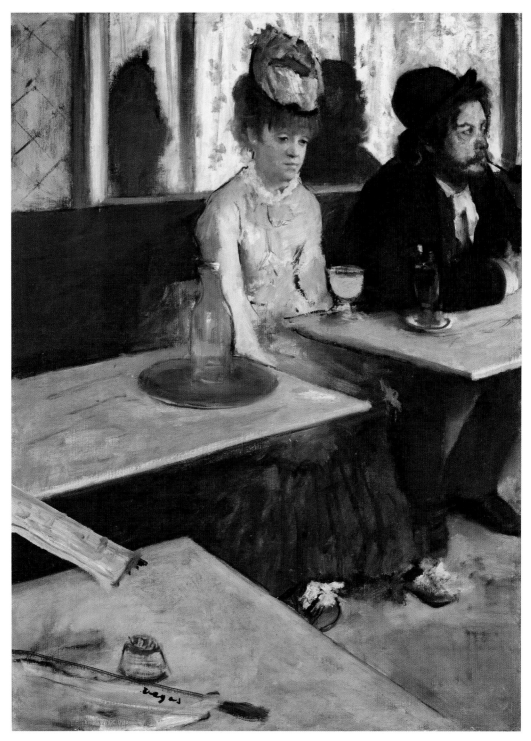

Edgar Degas (1834–1917)
Oil on canvas, 92 x 68 cm (36¼ x 26¾ in) • Musée d'Orsay, Paris

L'Absinthe, *c.* 1875–76 This is a scene of abject misery, suggested by the woman's body language and indifference of the male protagonist. At the bottom left is a newspaper with Degas' signature, suggesting that the image is reportage.

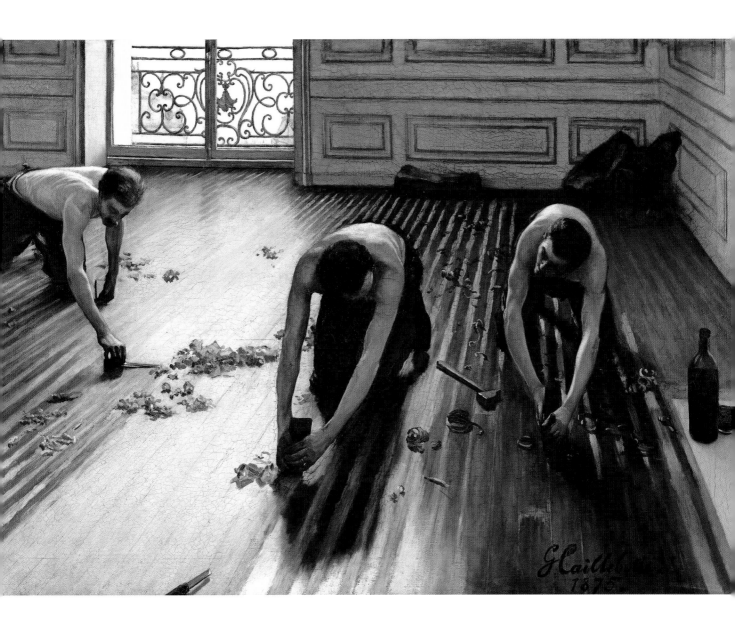

Gustave Caillebotte (1848–94)
Oil on canvas, 102 x 146 cm (40 x 57^1/$_2$ in) • Musée d'Orsay, Paris

The Floor Scrapers, 1875 This is an innovative work of social realism, in that its subject really has no precedent in painting. It depicts a group of working-class men preparing the floor of an apartment clearly belonging to a member of the bourgeoisie.

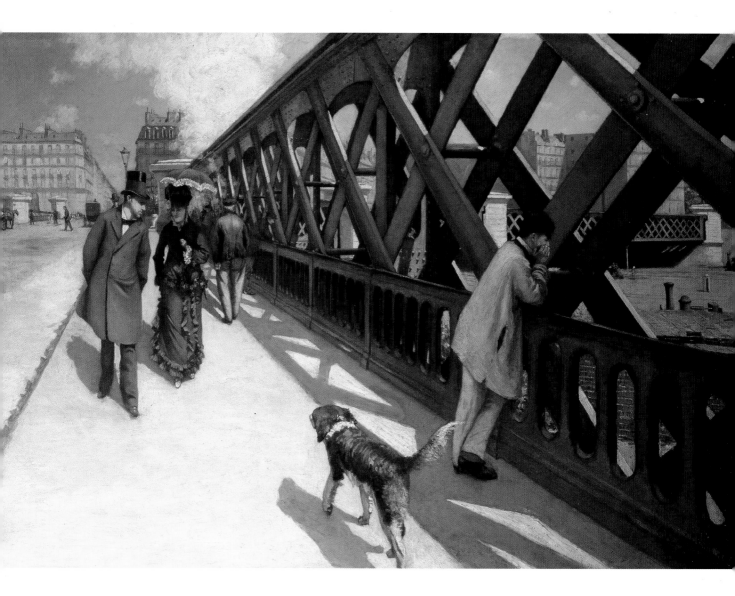

Gustave Caillebotte (1848–94)
Oil on canvas, 125 x 180 cm (49¼ x 70⅘ in) • Musée Petit Palais, Geneva

Le Pont de l'Europe, 1876 The dog walking in one direction, while the gentleman in the top hat, who may well be a *flâneur*, walks purposefully in the other, suggests the dynamism of a fast-moving modern Paris, its modernity emphasized by the iron bridge.

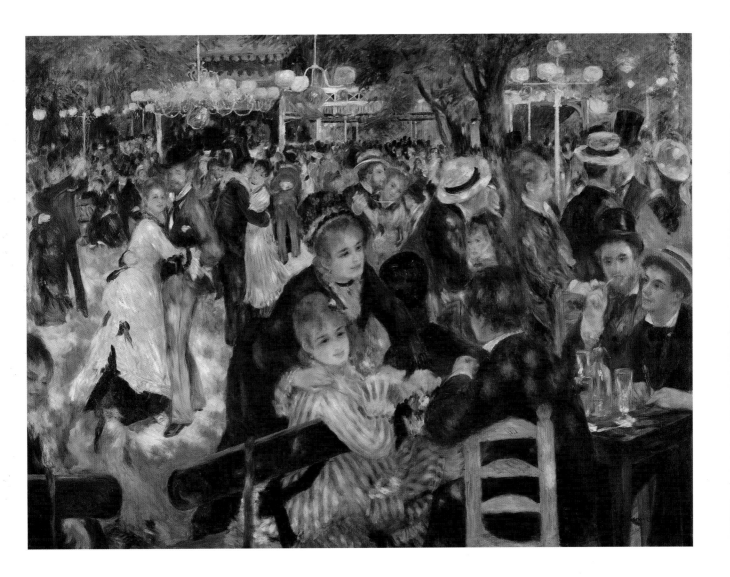

Pierre-Auguste Renoir (1841–1919)
Oil on canvas, 131 x 175 cm (51¹/₂ x 68⁴/₅ in) • Musée d'Orsay, Paris

The Ball at the Moulin de la Galette, 1876 This is a true masterpiece of Impressionist painting, which portrays the *joie de vivre* of a social group in dappled sunlight. It was painted *en plein air*, a remarkable achievement given the size of the canvas.

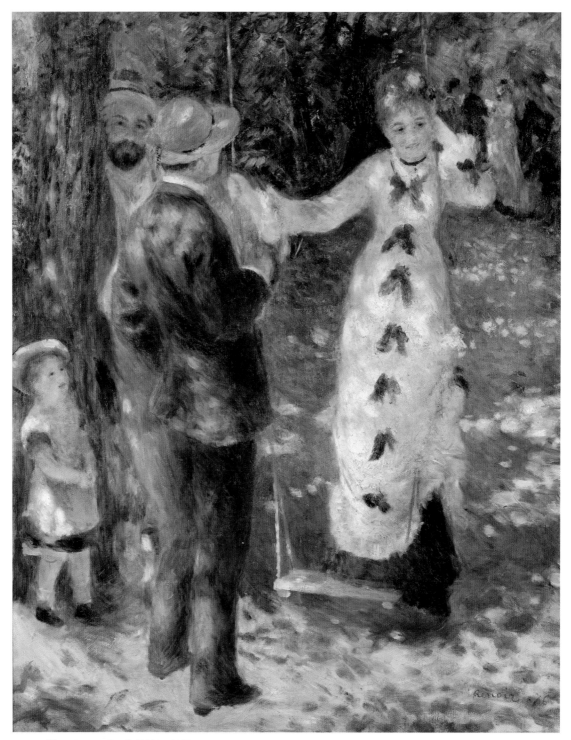

Pierre-Auguste Renoir (1841–1919)
Oil on canvas, 92 x 73 cm (36¼ x 28¾ in) • Musée d'Orsay, Paris

The Swing, 1876 The model for the painting is Jeanne, who also appeared in *The Ball at the Moulin de la Galette* (see page 43). The painting is a homage to the eighteenth-century painter Fragonard, but brought up to date with the appropriate fashion of the day.

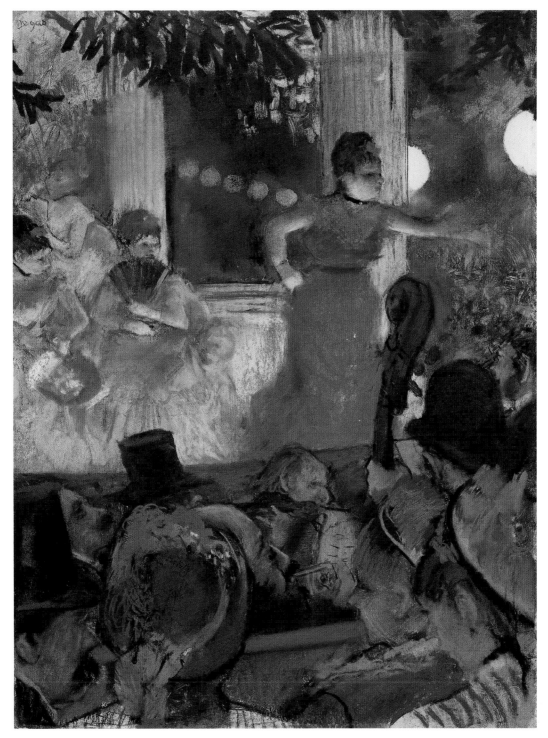

Edgar Degas (1834–1917)
Pastel on paper, 37 x 26 cm (14½ x 10¼ in) • Musée des Beaux-Arts, Lyon

Café-Concert at Les Ambassadeurs, 1876–77 Degas focuses on the female performer, who is reaching out to the audience, possibly teasing them with ribald wit and innuendo. The viewer of the picture is invited into this space by the inclusion of the foreground figures.

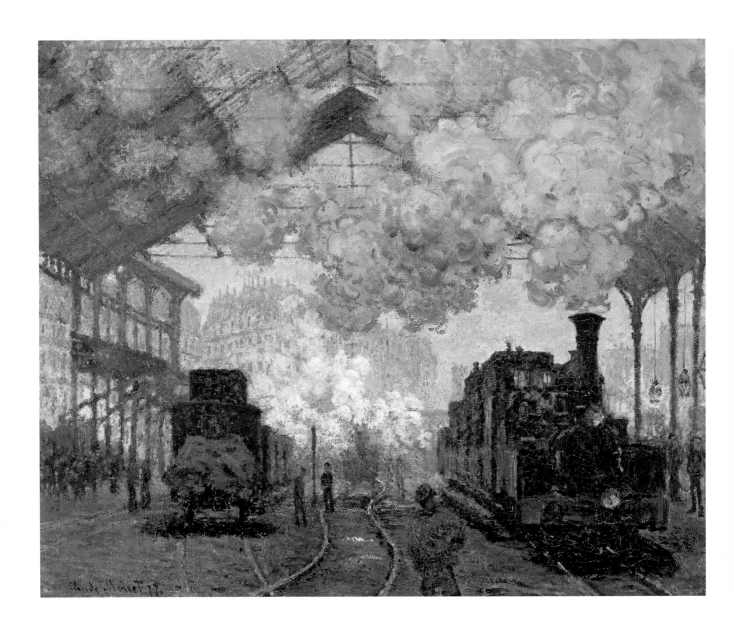

Claude Monet (1840–1926)
Oil on canvas, 80 x 98 cm (31²/₃ x 38²/₃ in) • Fogg Art Museum,
Harvard Art Museums

The Gare Saint-Lazare: Arrival of a Train, 1877 One of several pictures painted at this location, Monet was fascinated by the play of sunlight through the ethereal effects of smoke and steam, a theme that remained in much of his later work.

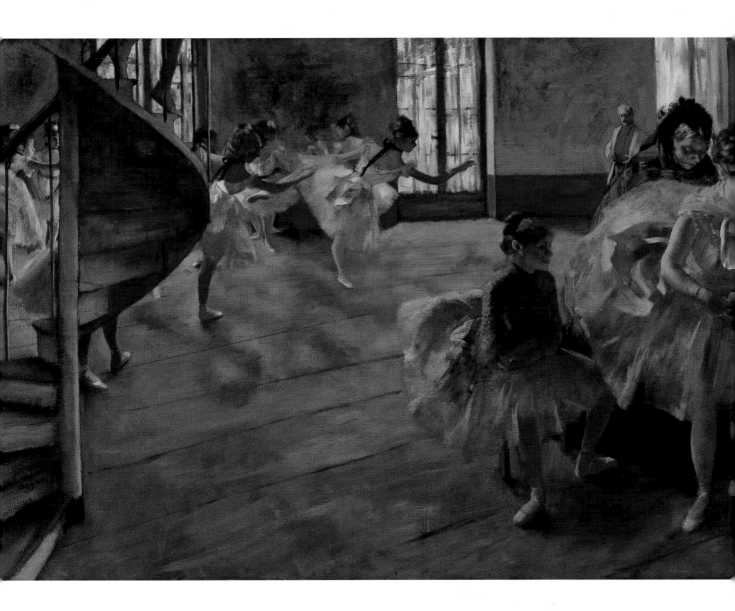

Edgar Degas (1834–1917)
Oil on canvas, 58.4 x 83.8 cm (23 x 33 in) • Burrell Collection, Glasgow

The Rehearsal, *c.* **1877** The serpentine structure of the staircase is a perfect compositional ploy, reflecting the arabesque poses of the dancers behind. It also helps to divide the active and passive elements of the composition.

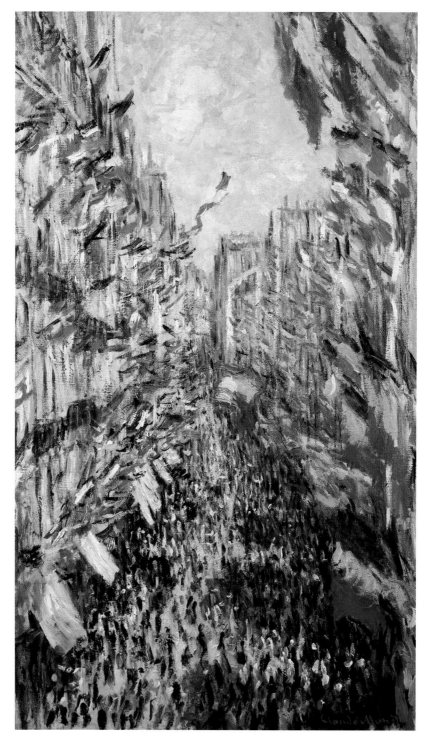

Claude Monet (1840–1926)
Oil on canvas, 80 x 48.5 cm (31^{1}/$_{2}$ x 19 in) • Musée d'Orsay, Paris

The Rue Montorgueil in Paris. Celebration of June 30th, 1878 This date marks a celebration held in Paris in honour of the Third Republic, which had been the official government since the end of the Franco-Prussian War. There had been opposition to the government in the previous year.

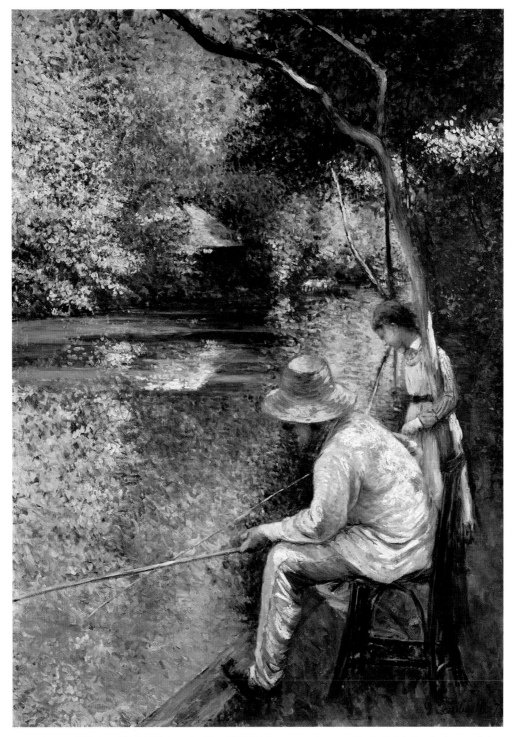

Gustave Caillebotte (1848–94)
Oil on canvas, 157 x 113 cm (61⁴/₅ x 44¹/₂ in) • Private Collection

Angling, 1878 This is an unusual composition for Caillebotte, who is normally known for his urban realist paintings. He has also lightened his palette and the brush marks are looser and more painterly.

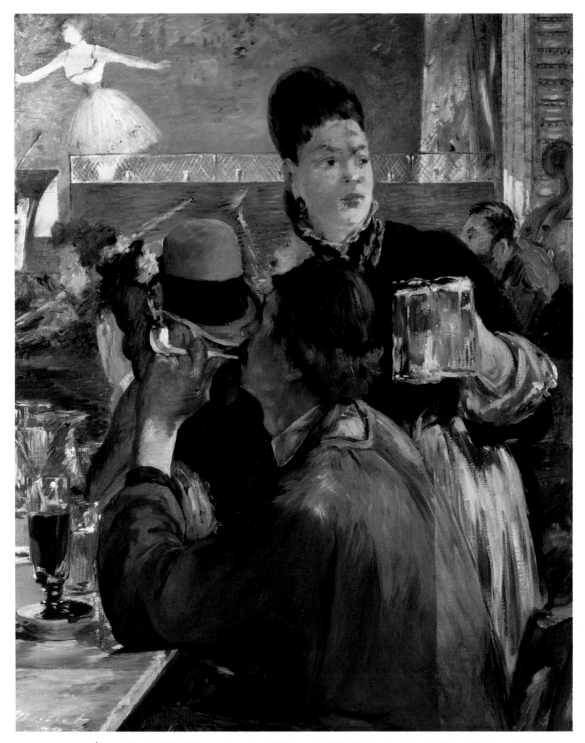

Édouard Manet (1832–83)
Oil on canvas, 97.1 x 77.5 cm (38¼ x 30½ in) • The National Gallery, London

Corner in a Café-Concert, 1878–80 Manet asked one of his models to pose for this picture as the waitress, which she accepted providing that her male partner could accompany her. He is seen in the foreground smoking a pipe.

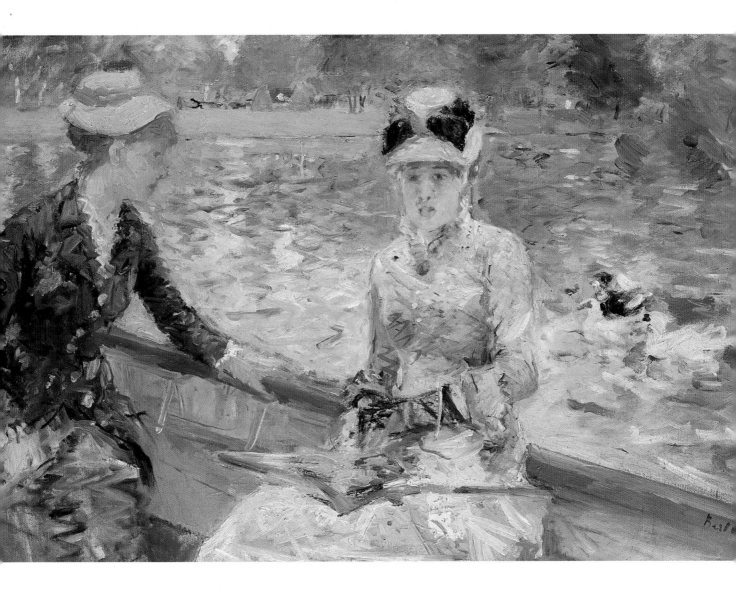

Berthe Morisot (1841–95)
Oil on canvas, 45.7 x 75.2 cm (18 x 29²/₃ in) • The National Gallery, London

Summer Day, 1879 A wonderfully bravura technique, as exemplified by the ducks on the water, is used in this painting. It was shown at the fifth Impressionist exhibition, the critics referring to it favourably as 'airy' and 'floating'.

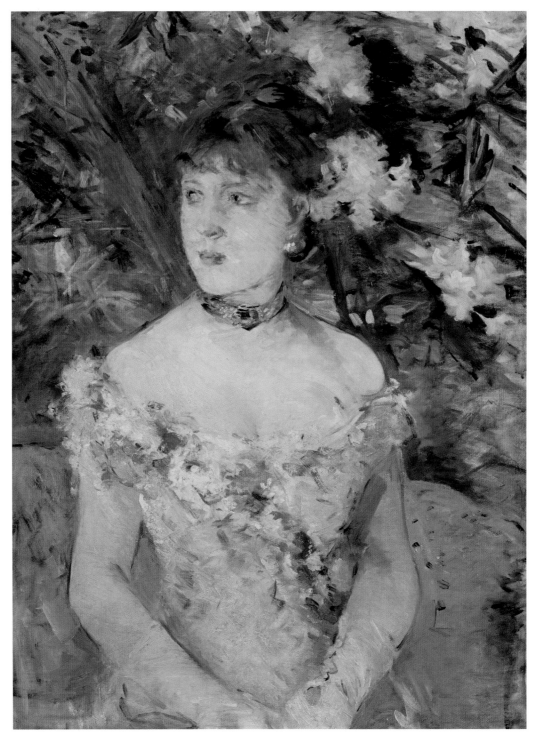

Berthe Morisot (1841–95)
Oil on canvas, 71 x 54 cm (28 x 21¼ in) • Musée d'Orsay, Paris

Young Girl in a Ball Gown, 1879 Although the sitter is unknown, she is typical of an haute bourgeois young woman, of the same class as Morisot herself. She is poised elegantly, with straight back, but otherwise given the same informality as the background flowers.

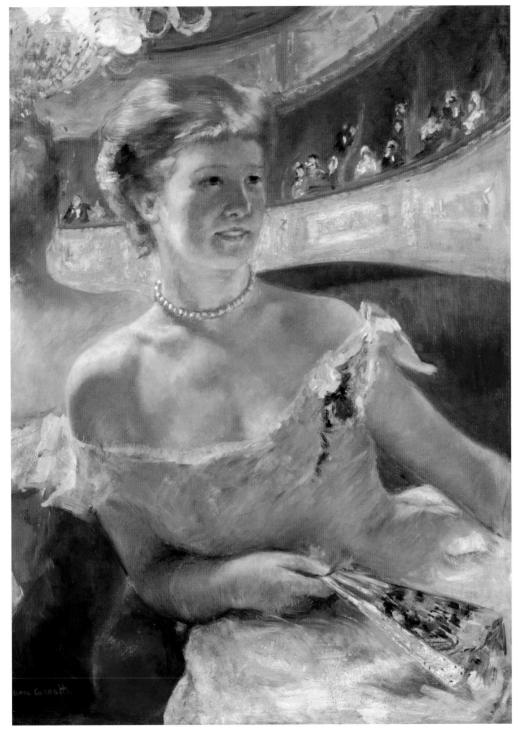

Mary Cassatt (1844–1926)
Oil on canvas, 81.3 x 59.7 cm (32 x 23¹/₂ in) • Philadelphia
Museum of Art

Woman with a Pearl Necklace in a Loge, 1879 Between 1878 and 1882, Cassatt devoted her
considerable skills to portraying women at the theatre. The sitter's eyes don't return the viewer's gaze,
unlike those depicted by Renoir and Degas.

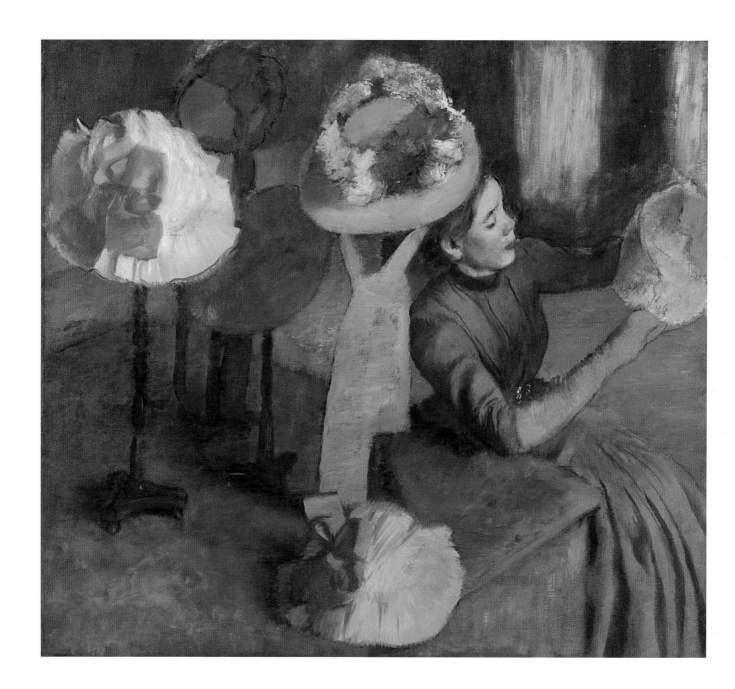

Edgar Degas (1834–1917)
Oil on canvas, 100 x 110.7 cm (39²/₅ x 43¹/₂ in) • The Art Institute
of Chicago

The Millinery Shop, 1879–96 The unusual angle of view portrays the shop assistant as unaware of the artist's presence as a *flâneur*. Degas was fascinated by the latest women's fashions and often accompanied Mary Cassatt on shopping expeditions.

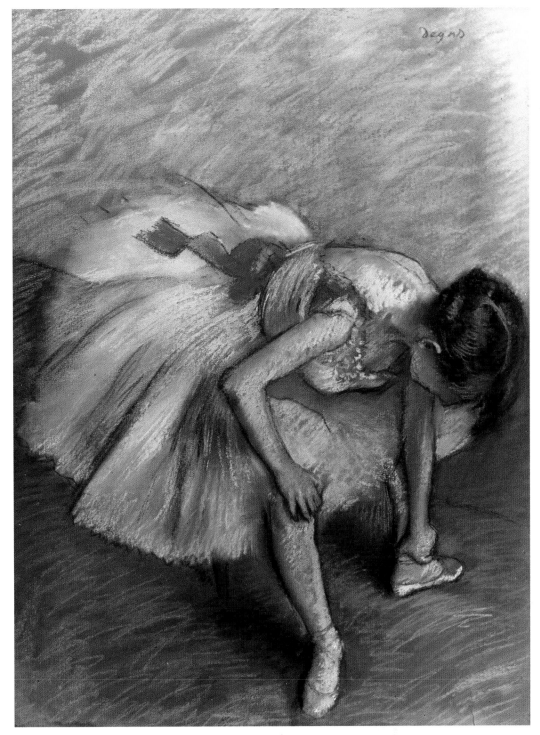

Edgar Degas (1834–1917)
Pastel on paper, 62 x 49 cm (24²/₅ x 19¹/₃ in) • Musée d'Orsay, Paris

Seated Dancer, *c.* **1881–83** An aspect of Degas' dance pictures that differs from the mainstream is the way he depicted them after their class, examination or performance. This dancer looks exhausted and is possibly rubbing a sore ankle.

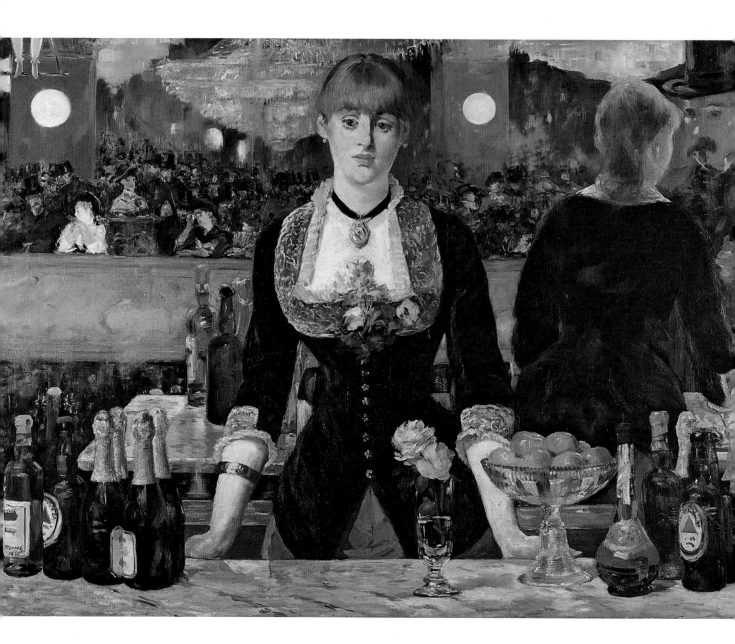

Édouard Manet (1832–83)
Oil on canvas, 96 x 130 cm (37³/₄ x 50 in)
• The Courtauld Gallery, London

A Bar at the Folies-Bergère, 1881–82 Executed by Manet shortly before his death, it is a highly ambiguous painting that seems to defy the conventions associated with traditional narratives. Note, for example, the legs of a trapeze artist in the top left-hand corner.

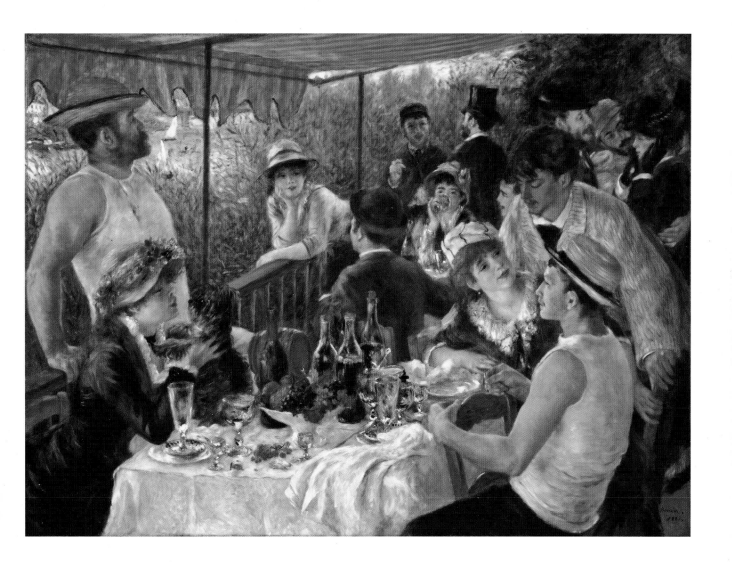

Pierre-Auguste Renoir (1841–1919)
Oil on canvas, 130.2 x 175.6 cm (51¼ x 69 in) • The Philips Collection,
Washington DC

Luncheon of the Boating Party, 1880-81 On the left-hand side of the joyous picture is Aline
Charigot, Renoir's mistress and later wife, with whom he had three sons. The scene is at the
Restaurant Fournaise, its proprietor standing behind Aline.

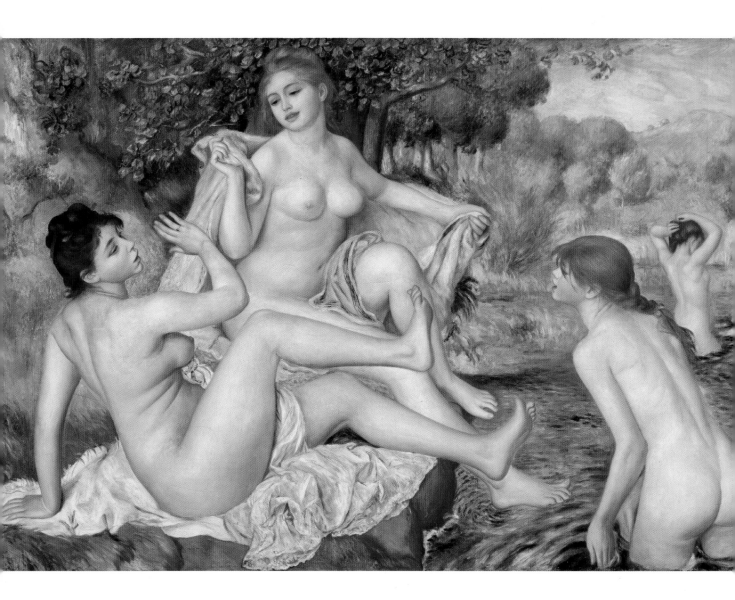

Pierre-Auguste Renoir (1841–1919)
Oil on canvas, 117.8 x 170.8 cm (46³/₄ x 67¹/₄ in) • Philadelphia
Museum of Art

The Large Bathers, 1884–87 This work is the epitome of Renoir's new style, first begun after his so-called 'dry period' earlier in the decade. He made many sketches and preliminary drawings for the work, hence the long gestation period.

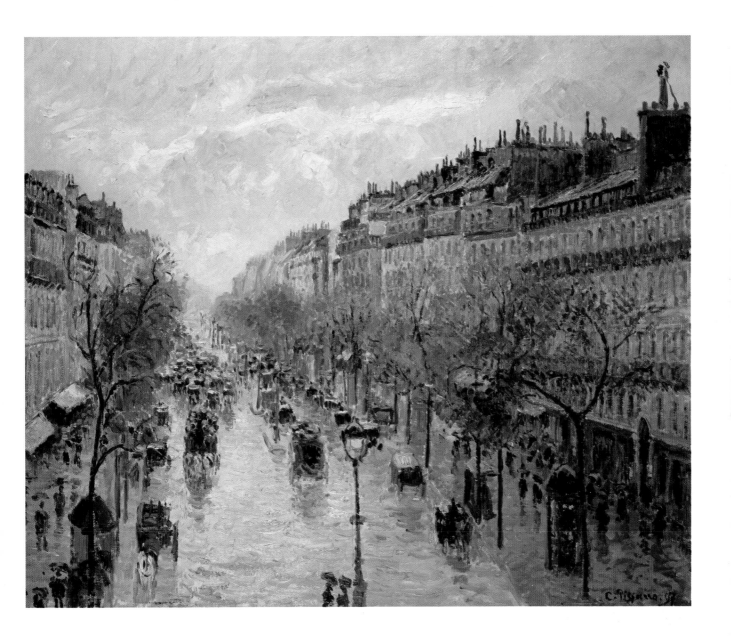

Camille Pissarro (1830–1903)
Oil on canvas, 54.1 x 65.1 cm (21¹/₃ x 25²/₃ in) • Private Collection

Boulevard Montmartre, 1897 In the autumn years of his life, Pissarro executed a number of oil paintings of city life from a high vantage point. This is one of 14 depictions of this boulevard and depicts spring in the rain.

Light & Landscape

Northern France, like southern England, has a continually changing light, which artists have sought to capture on canvas since the eighteenth century, none more successfully so than the Impressionists.

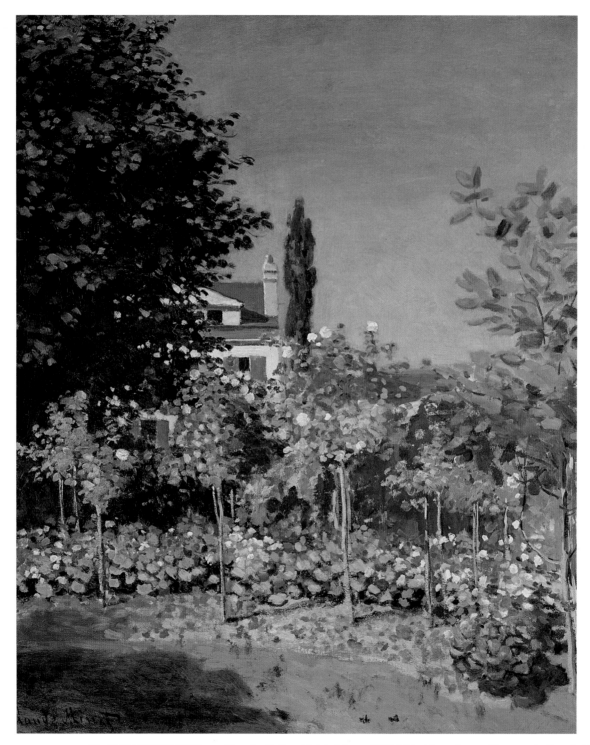

Claude Monet (1840–1926)
Oil on canvas, 65 x 54 cm (25²/₃ x 21¹/₄ in) • Musée d'Orsay, Paris

Flowering Garden at Sainte-Adresse, 1866 Sainte-Adresse is a small town near Le Havre that Monet knew as a child, returning here many times in the 1860s. Known mainly for its beach and fishing boats, which he painted, it was also renowned for its gardens.

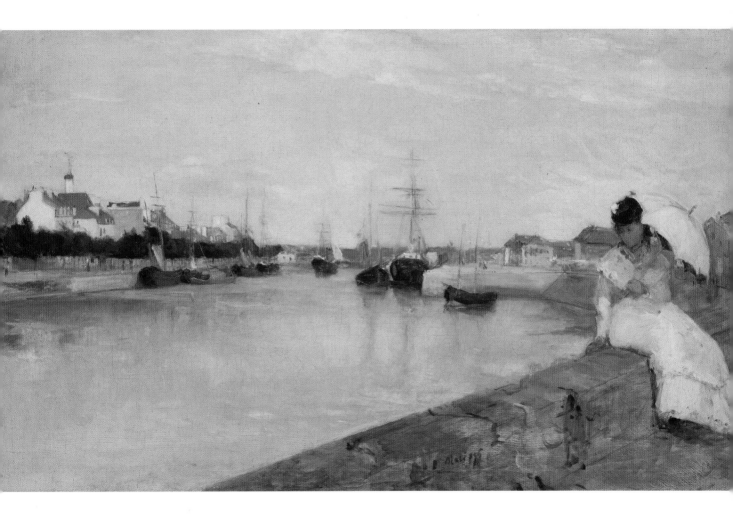

Berthe Morisot (1841–95)
Oil on canvas, 43.5 x 73 cm (17 x 28³/₄ in) • National Gallery of Art,
Washington DC

The Harbour at Lorient, 1869 The scene painted here is redolent of the Barbizon school of painting, but is already beginning to show the lightening of the palette that made it an early Impressionist work.

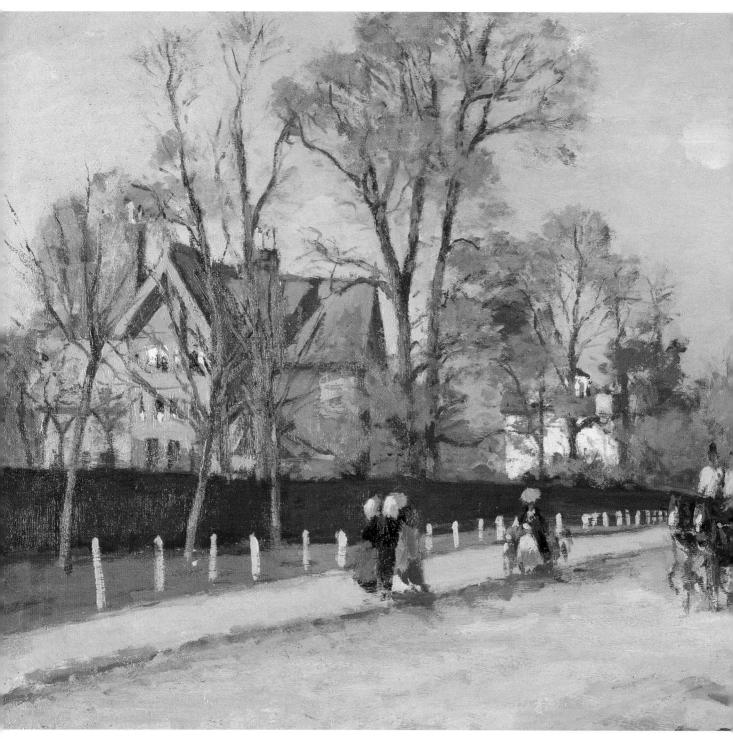

Camille Pissarro (1830–1903)
Oil on canvas, 48 x 73 cm (18⁴/₅ x 28³/₄ in) • The National Gallery, London

The Avenue, Sydenham, 1871 An unusually large canvas for Pissarro to be working on, it has all the hallmarks of an earlier painting executed the year before in Louveciennes. It was painted while the artist was in exile in London in 1870–71.

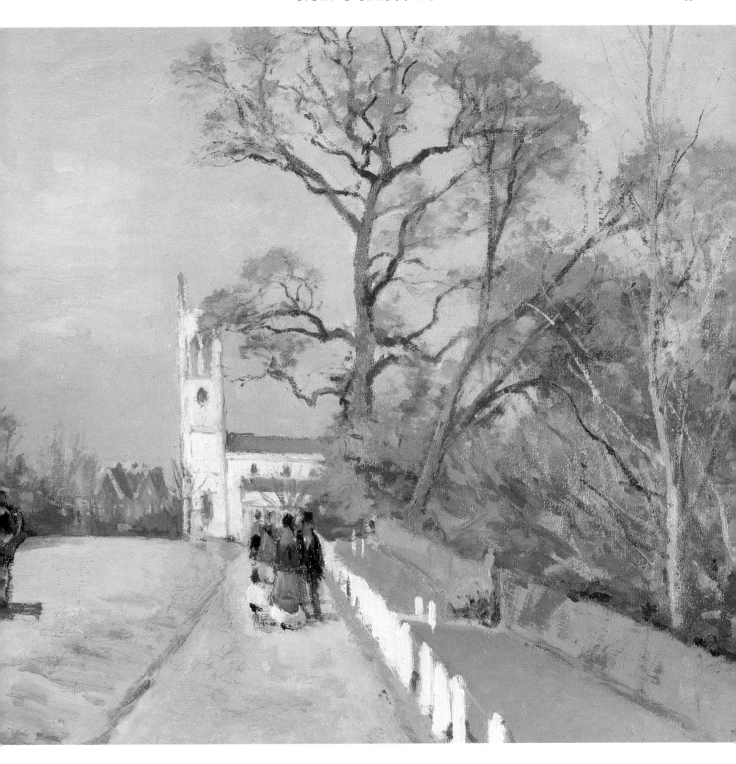

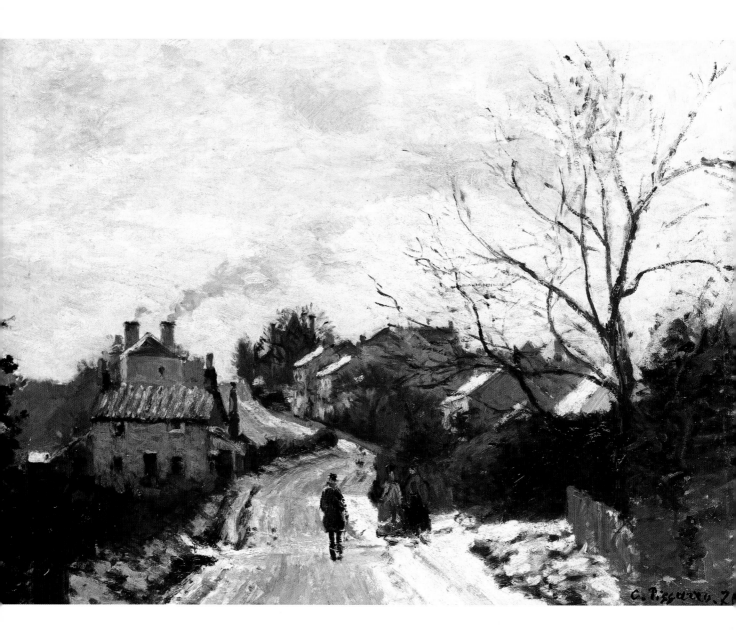

Camille Pissarro (1830–1903)
Oil on canvas, 35.3 x 45.7 cm (13⁴/₅ x 18 in) • The National Gallery, London

Fox Hill, Upper Norwood, 1870 When talking about his voluntary exile with Monet in England, Pissarro once remarked that 'he (Monet) worked in the parks, whilst I, living at Lower [sic] Norwood ... studied the effects of mist, snow and springtime'.

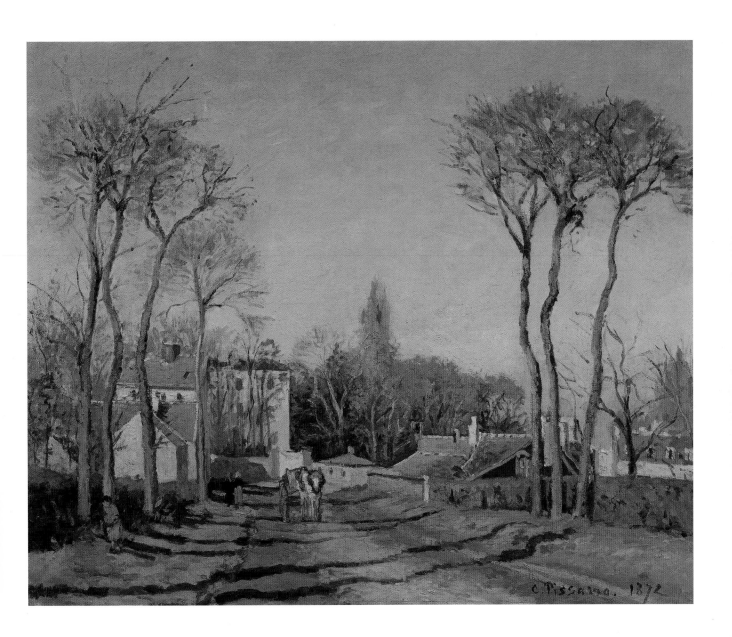

Camille Pissarro (1830–1903)
Oil on canvas, 46 x 55.5 cm (18 x 21⁴/₅ in) • Musée d'Orsay, Paris

Entrance to the Village of Voisins, Yvelines, 1872 This is one of the first paintings Pissarro executed on his return to France from London. He stayed in Voisins until 1872 before moving to Pontoise, where he remained for the next 10 years.

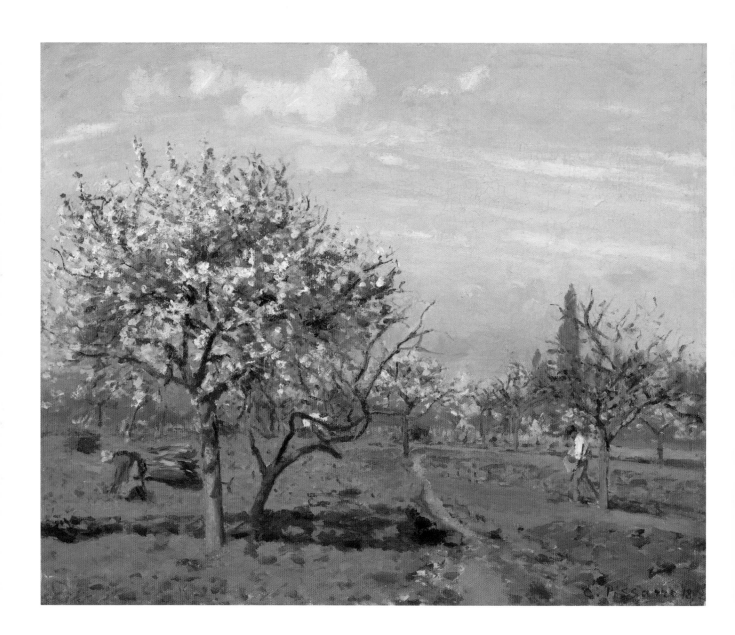

Camille Pissarro (1830–1903)
Oil on canvas, 45.1 x 54.9 cm (17³/₄ x 21²/₃ in) • National Gallery of Art,
Washington, DC

Orchard in Bloom, Louveciennes, 1872 Louveciennes, like several other suburbs to the west of Paris along the Seine, was attractive as a weekend leisure resort for Parisians. Accessible by rail, it offered a degree of relative peace away from the city.

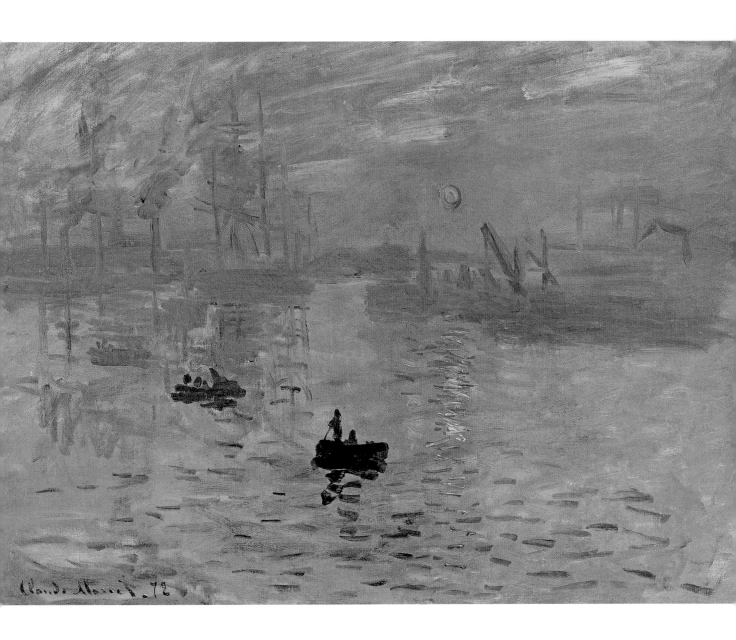

Claude Monet (1840–1926)
Oil on canvas, 48 x 63 cm (18⁴/₅ x 24⁴/₅ in) • Musée Marmottan
Monet, Paris

Impression: Sunrise, 1872 It is very likely that Monet saw the work of the English painter J.M.W. Turner during his stay in London in 1870–71, and was influenced by the ethereal effects of painting a scene directly into the sunlight.

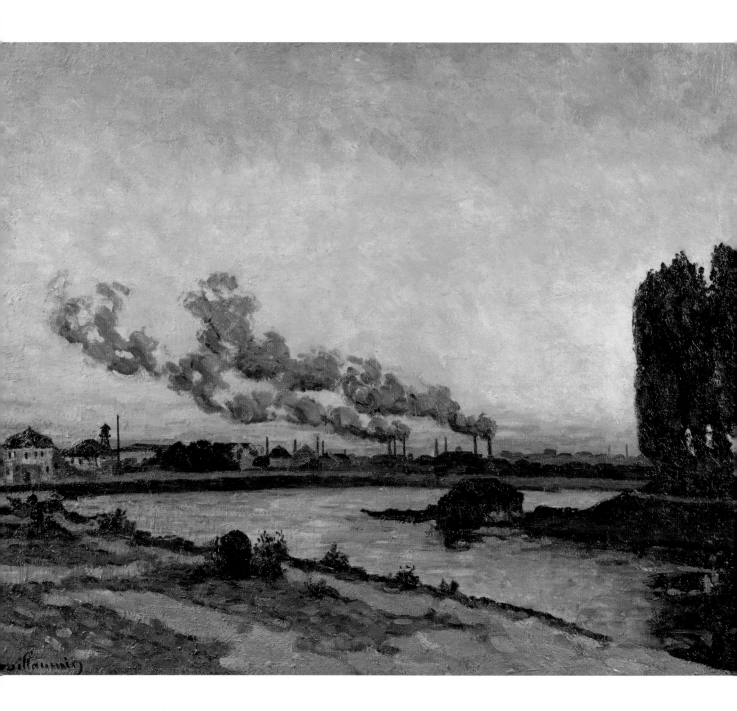

Armand Guillaumin (1841–1927)
Oil on canvas, 65 x 18 cm (25^1/$_2$ x 7 in) • Musée d'Orsay, Paris

Sunset at Ivry, c. 1872–73 The Impressionists engaged with modernity at all levels. In this painting, against a background of industrialization, Guillaumin seeks to embrace nature's wonderful sunset in a way that is redolent of the 'sublime', a tradition in the English paintings of Turner.

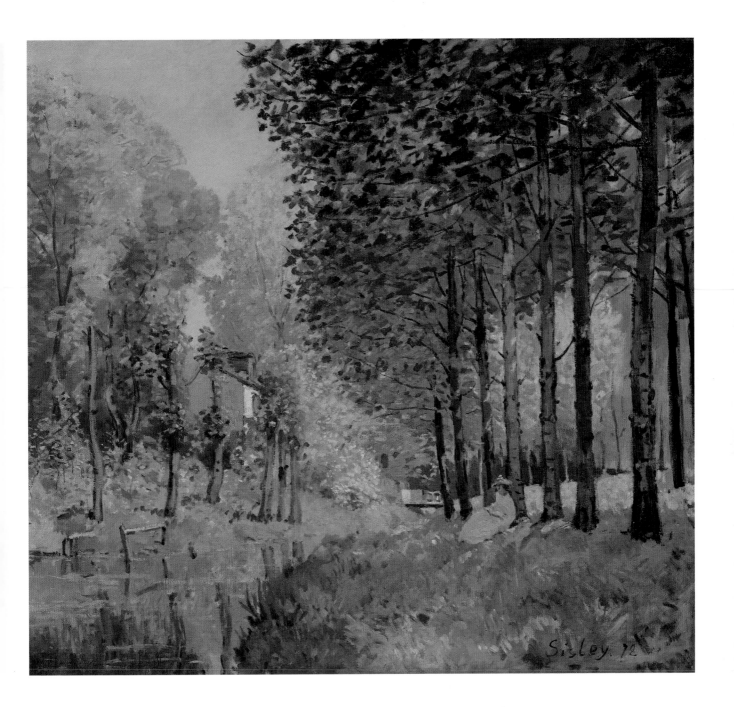

Alfred Sisley (1839–99)
Oil on canvas, 73.5 x 80.5 cm (29 x 31¾ in) • Musée d'Orsay, Paris

The Rest by the Stream, Edge of the Wood, 1872 A very tranquil picture that was never exhibited in Sisley's lifetime, the scene is likely to be close to Louveciennes, where he lived until he moved to Marly-le-Roi in 1875.

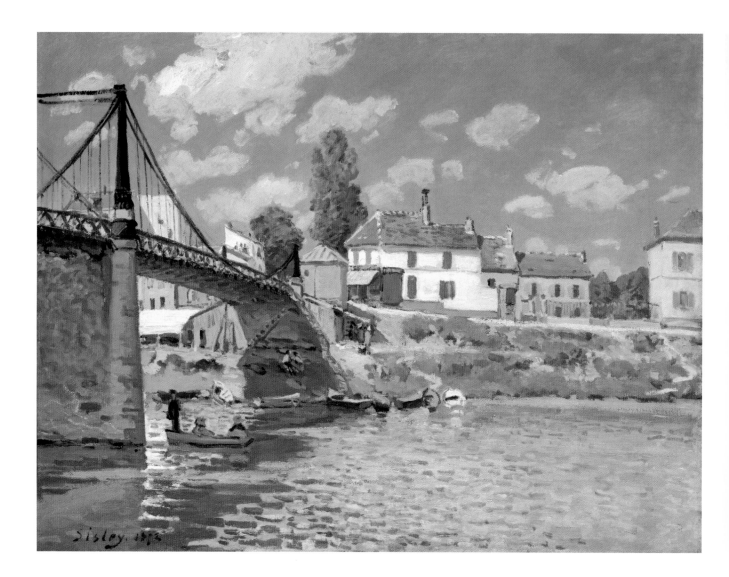

Alfred Sisley (1839–99)
Oil on canvas, 49.5 x 65.4 cm (19$\frac{1}{2}$ x 25$\frac{3}{4}$ in) • Metropolitan Museum
of Art, New York

The Bridge at Villeneuve-la-Garenne, 1872 The cast-iron and stone suspension bridge, built in 1844, dwarfs the people in the boat, and is the focal point of the picture as it draws the viewer towards the newly built modern housing across the river.

Alfred Sisley (1839–99)
Oil on canvas, 54 x 73 cm (21¼ x 28¾ in) • Musée d'Orsay, Paris

Rue de la Machine, Louveciennes, 1873 This road leads down to the Machine de Marly, an elaborate pumping station commissioned by Louis XIV and built in 1684 to pump water from the Seine up to his fountains at Versailles.

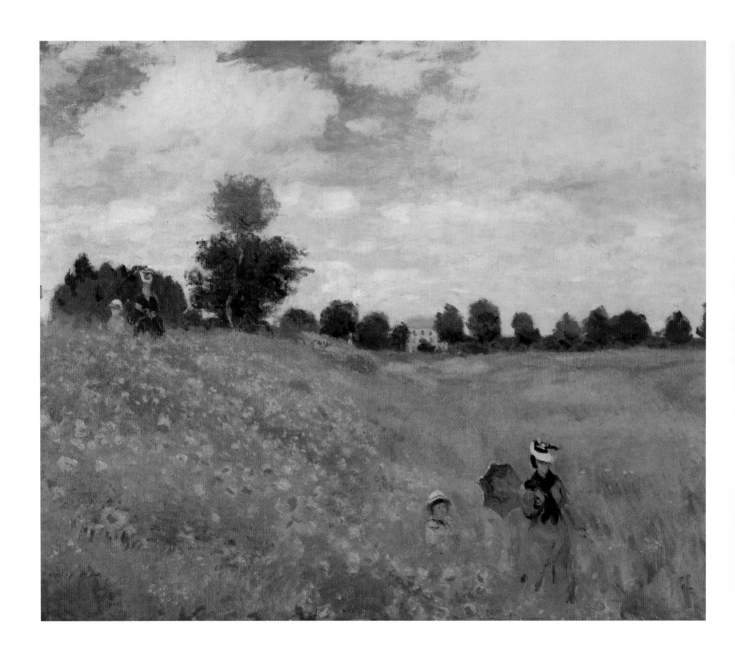

Claude Monet (1840–1926)
Oil on canvas, 50 x 65 cm (19²/₃ x 25¹/₂ in) • Musée d'Orsay, Paris

Wild Poppies, Near Argenteuil, 1873 Emile Zola once said of Monet that: 'he takes Paris with him to the country', as evidenced in this painting, which shows mothers in the latest Parisian fashions walking through the fields with their children.

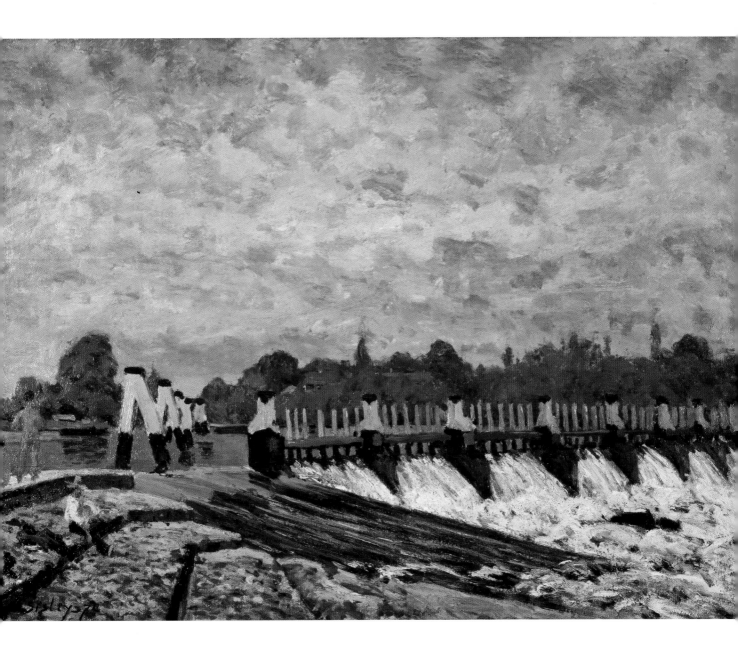

Alfred Sisley (1839–99)
Oil on canvas, 51.5 x 68.6 cm (20¼ x 27 in) • Scottish National
Gallery, Edinburgh

Molesey Weir, Hampton Court, 1874 In July 1874, Sisley returned to London for the first time since his business studies, living on the city's outskirts at Hampton Court and painting a number of views of this stretch of the River Thames.

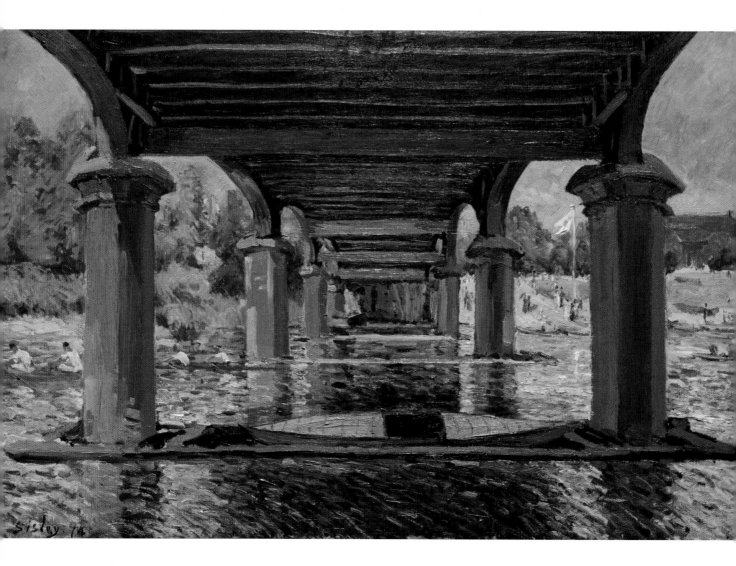

Alfred Sisley (1839–99)
Oil on canvas, 50 x 76 cm (19²/₃ x 30 in) • Kunstmuseum, Winterthur

Under the Bridge at Hampton Court, 1874 This is a compositionally complex painting that required much study and contemplation to achieve the desired result. The permanence of a brick and steel bridge is set against a transitory moment, passing rowers watched by a small crowd on the riverbank.

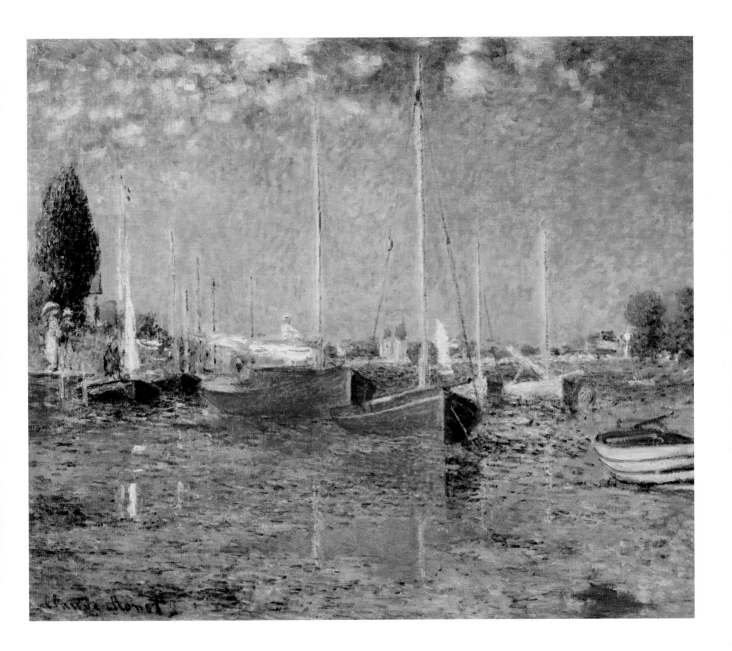

Claude Monet (1840–1926)
Oil on canvas, 56 x 65 cm (22 x 25²/₃ in) • Musée de l'Orangerie, Paris

Argenteuil, *c.* **1872–75** Argenteuil was the scene of many weekend regattas on the River Seine, and painted by many of the Impressionists. The stretch of river is straight here, so crowds could gather to watch.

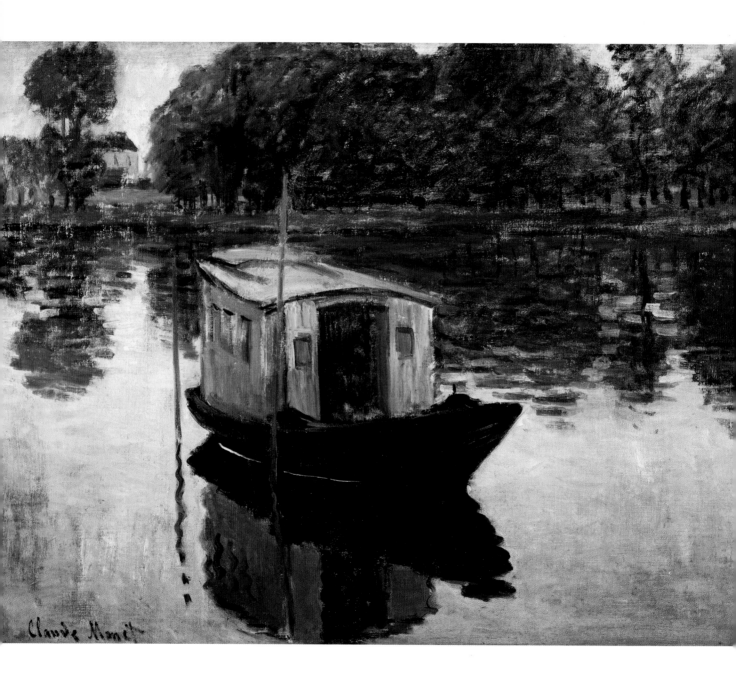

Claude Monet (1840–1926)
Oil on canvas, 50 x 64 cm (19²/₃ × 25¹/₄ in) • Kröller-Müller
Museum, Otterlo

The Studio Boat, 1874 Monet had this studio boat built so he could paint riverbank scenes from the water, giving his pictures a new perspective. Manet executed a painting of Monet working in his boat.

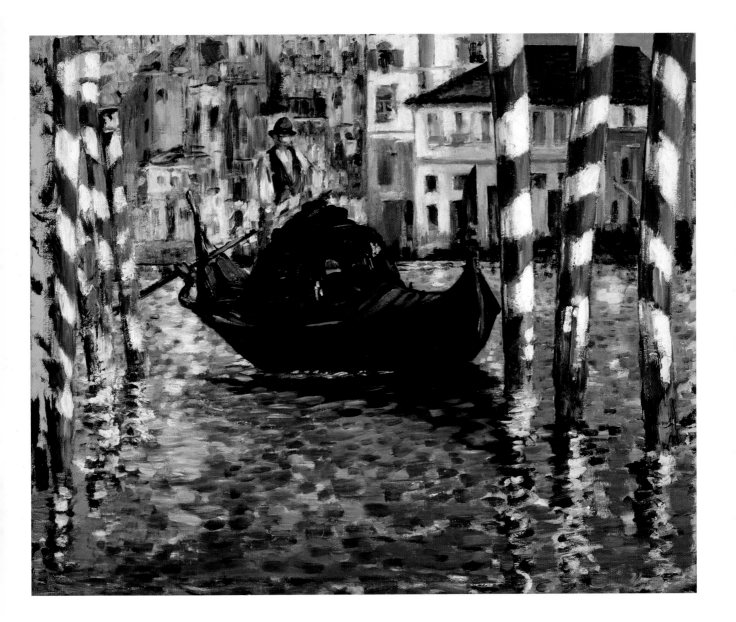

Édouard Manet (1832–83)
Oil on canvas, 58.7 x 71.4 cm (23 x 28 in)
• Shelburne Museum, Vermont

The Grand Canal of Venice, 1875 Manet visited Venice in 1874 with fellow artist James Tissot. The perspective of the work suggests that it may have been sketched from a gondola, given the foreground prominence of the mooring posts.

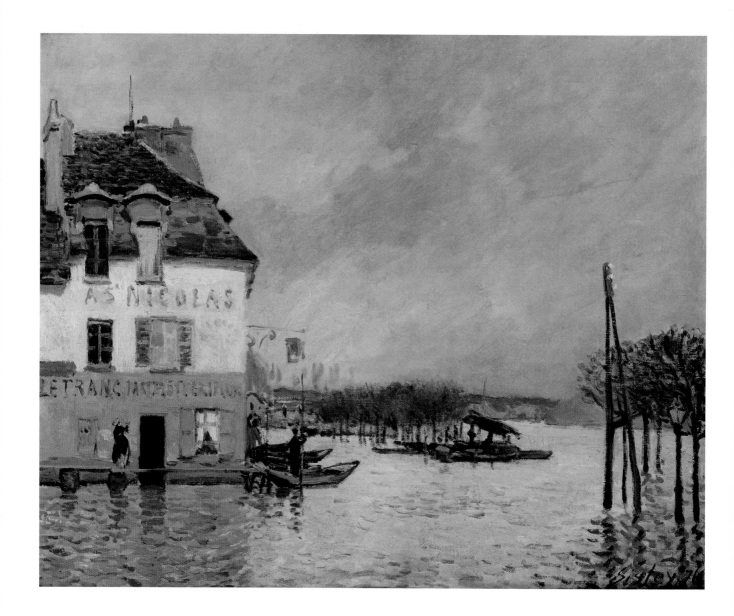

Alfred Sisley (1839–99)
Oil on canvas, 50 x 61.5 cm (19²/₃ x 24¹/₄ in) • Musée des Beaux-Arts
Andre Malraux, Le Havre

The Flood at Port-Marly, 1876 One of several versions Sisley painted that recorded the flooding when the River Seine burst its banks in March 1876. The masterful composition makes it one of the most striking Impressionist pictures ever painted.

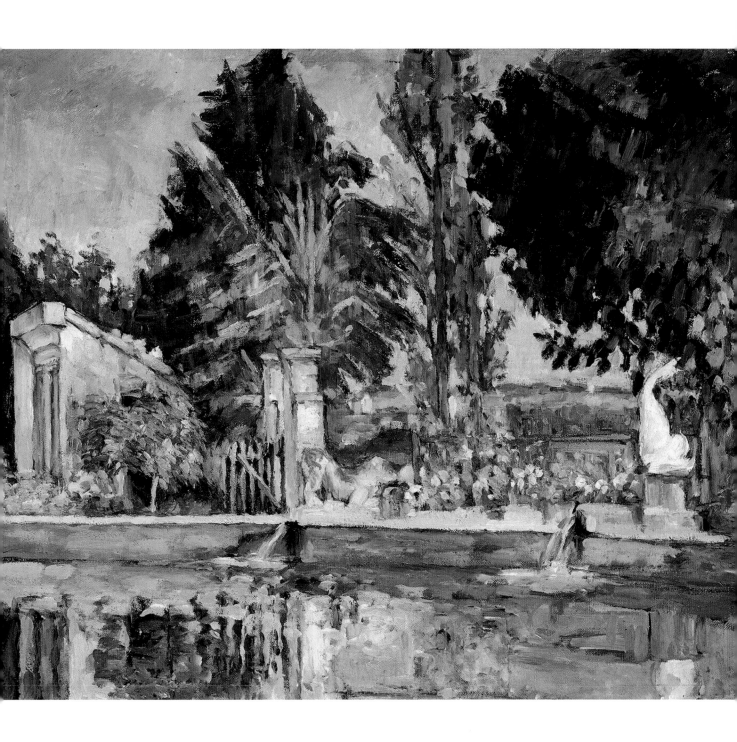

Paul Cézanne (1839–1906)
Oil on canvas, 46.1 x 56.3 cm (18 × 22¹/₄ in) • State Hermitage
Museum, St Petersburg

Jas de Bouffan, The Pool, *c.* **1876** This painting depicts the home of Cézanne's wealthy parents in
Aix-en-Provence. Cézanne spent part of his time here, where his father had a studio built for him in the
1880s, when he needed some artistic isolation away from Paris.

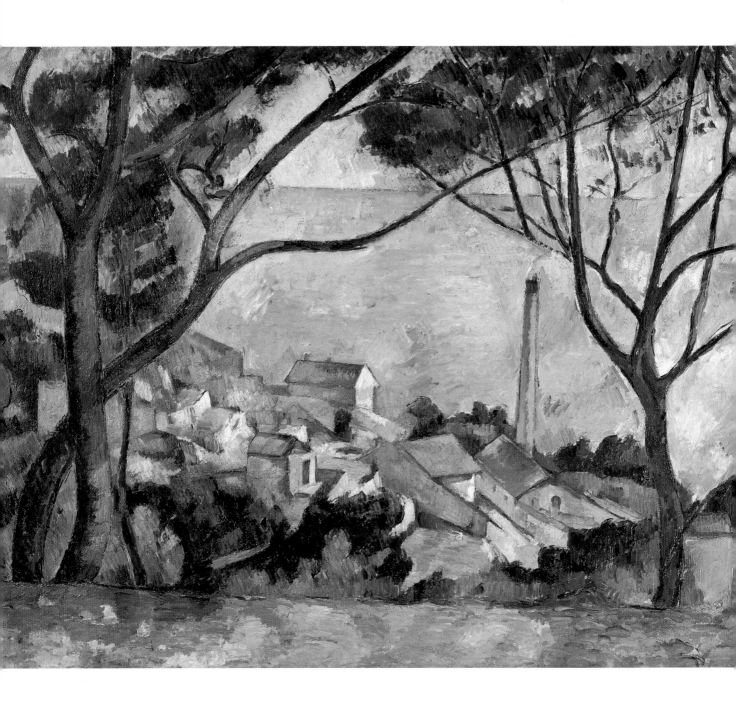

Paul Cézanne (1839–1906)
Oil on canvas, 73 x 92 cm (28³/₄ x 36 in) • Musée Picasso, Paris

The Sea at L'Estaque, 1878 At this time, Cézanne is moving away from Impressionism towards a form of decorative flat painting, in which natural objects are condensed into geometric shapes such as the cone, cylinder and cube.

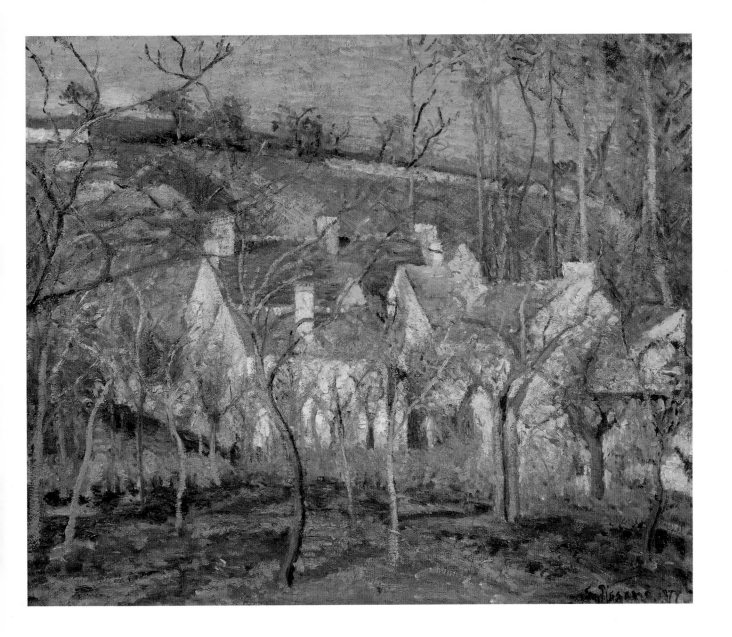

Camille Pissarro (1830–1903)
Oil on canvas, 54.5 x 65.5 cm (21²/₅ x 25³/₄ in) • Musée d'Orsay, Paris

The Red Roofs, or Corner of a Village, Winter, 1877 The red roofs are the subject of the painting rather than forming part of a conventional landscape. We are unable to make out the houses clearly because of the bright sunlight and the tangled mass of winter trees.

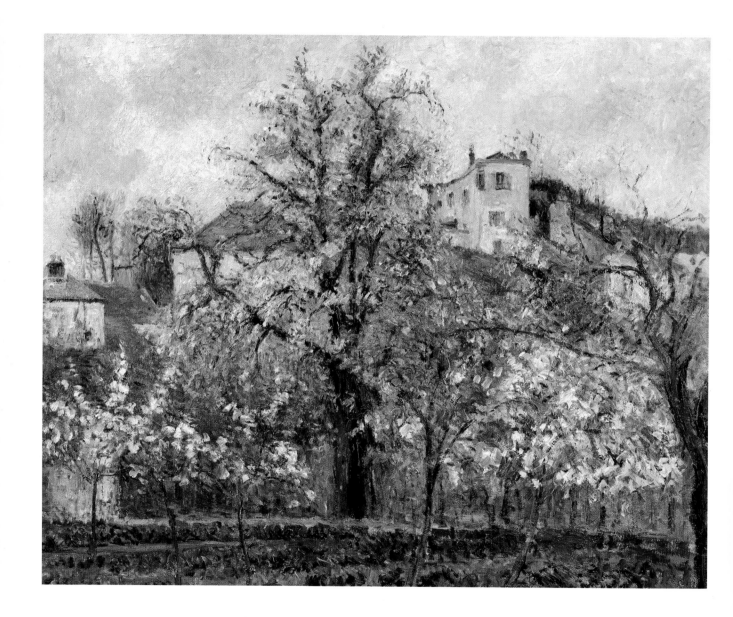

Camille Pissarro (1830–1903)
Oil on canvas, 65.5 x 81 cm (25³/₄ x 31⁴/₅ in) • Musée d'Orsay, Paris

Vegetable Garden with Trees in Blossom, Spring, Pontoise, 1877 The most striking part of this painting is the thick impasto work Pissarro has used for the blossom, liberally applying a variety of other colours in small dabs to accentuate the white blossom and the stuccoed houses at the top of the hill.

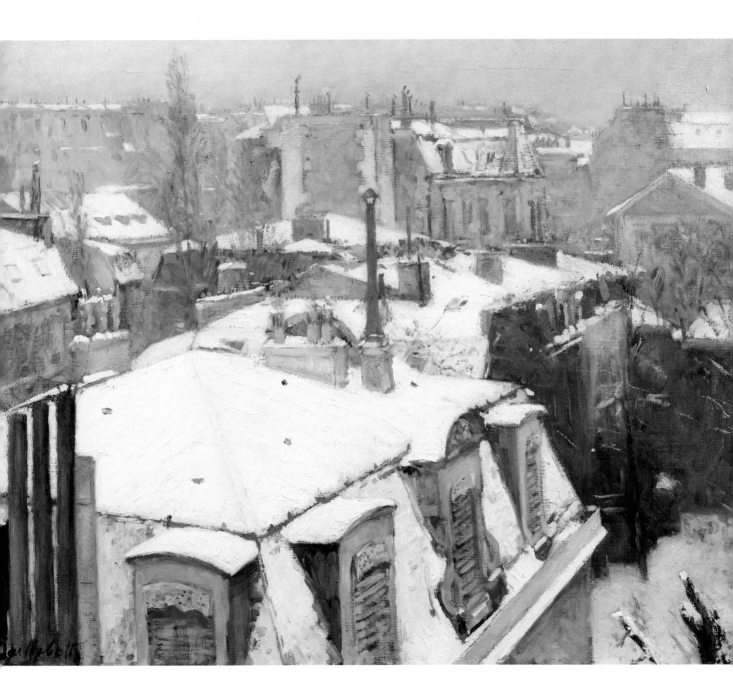

Gustave Caillebotte (1848–94)
Oil on canvas, 64 x 82 cm (25¼ x 32¼ in) • Musée d'Orsay, Paris.

View of Roofs (Snow Effect), 1878 Caillebotte produced a number of paintings from a high vantage point, but usually populated. It is more Impressionist in style than his normal Realist mode, as suggested by the title.

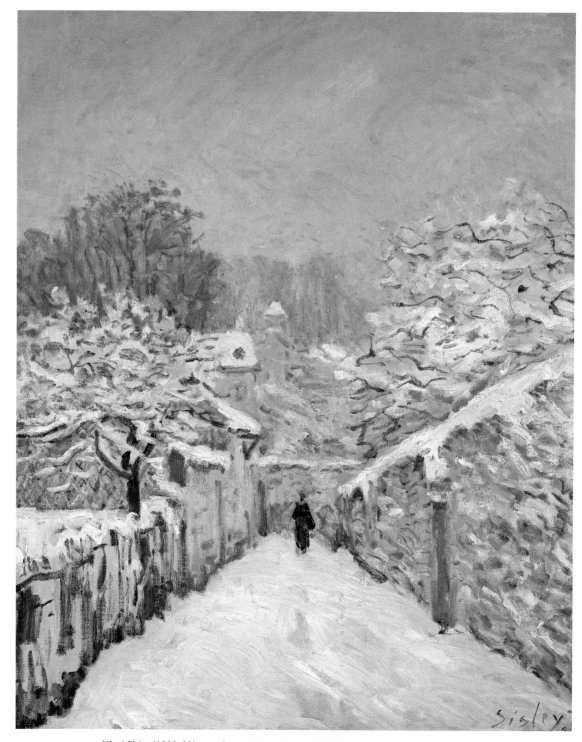

Alfred Sisley (1839–99)
Oil on canvas, 61 x 50.5 cm (24 x 19⁴/₅ in) • Musée d'Orsay, Paris

Snow at Louveciennes, 1878 This small lane is off the Rue Princesse, where Sisley lived. He completed a number of these paintings at different times of the year, composing them in a portrait format, unusual for landscapes.

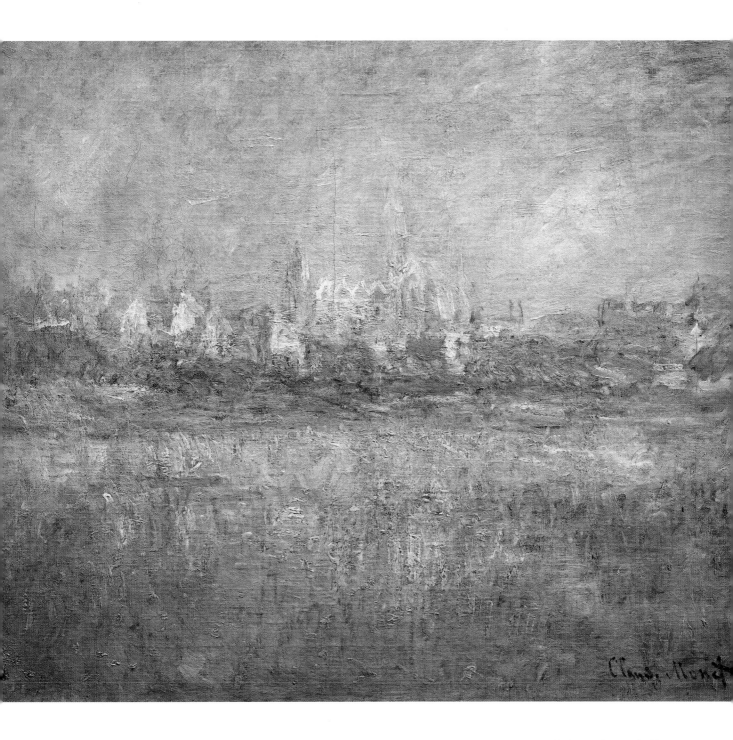

Claude Monet (1840–1926)

Oil on canvas, 60 x 71 cm (23²/₃ x 28 in) • Musée Marmottan Monet, Paris

Vétheuil in the Fog, 1879 This atmospheric and ethereal image heralded a new departure for Monet, as he sought to capture the effects of light on a landscape or building rather than the detail of the motif itself.

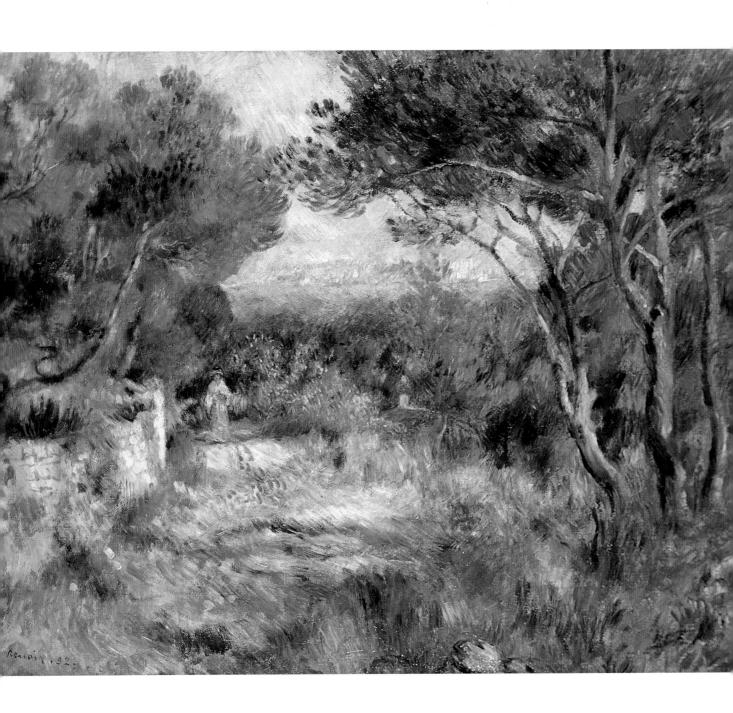

Pierre-Auguste Renoir (1841–1919)
Oil on canvas, 65.8 x 81 cm (26 x 31⁴/₅ in) • Private Collection

L'Estaque, 1882 In 1882, Renoir went to stay with Cézanne in Marseilles en route from Italy to Paris. They made several trips to the nearby bay at L'Estaque and painted together.

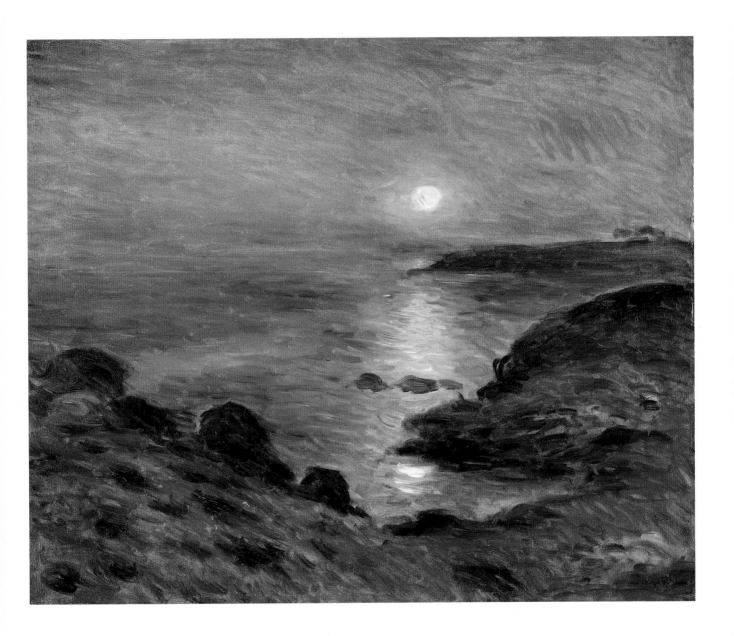

Pierre-Auguste Renoir (1841–1919)
Oil on canvas, 54.3 x 66.1 cm (21$^{1}/_{3}$ x 26 in) • Private Collection

The Setting of the Sun at Douarnenez, 1883 Renoir spent the summers of 1882 and 1883 at Wargemont on the Brittany coast, as he was entering his so-called 'dry period', when he declared Impressionism was 'at a dead end'.

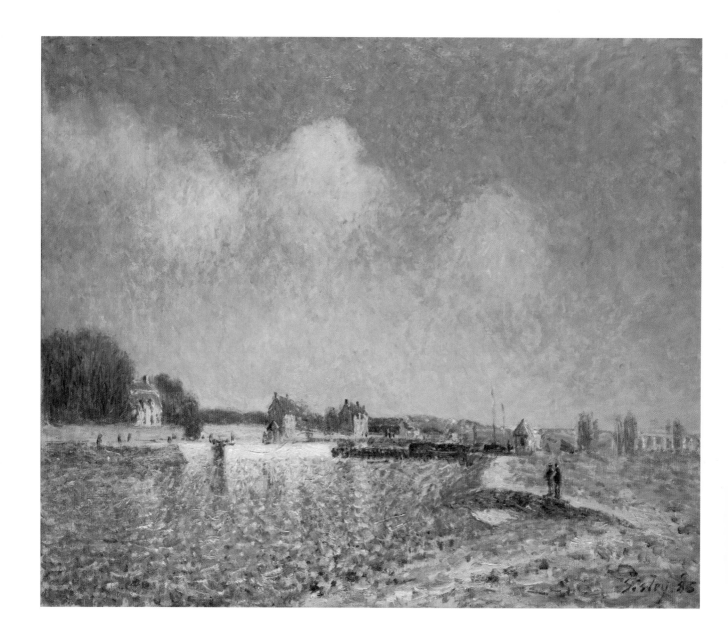

Alfred Sisley (1839–99)
Oil on canvas, 45 x 34.8 cm (17³/₄ x 13³/₄ in) • Private Collection

The Lock at Saint-Mammès, 1885 Sisley visited the port of Saint-Mammès at the confluence of the rivers Seine and Loing in the 1880s. The intense band of white highlights the sunlight catching the water as it flows from the lock.

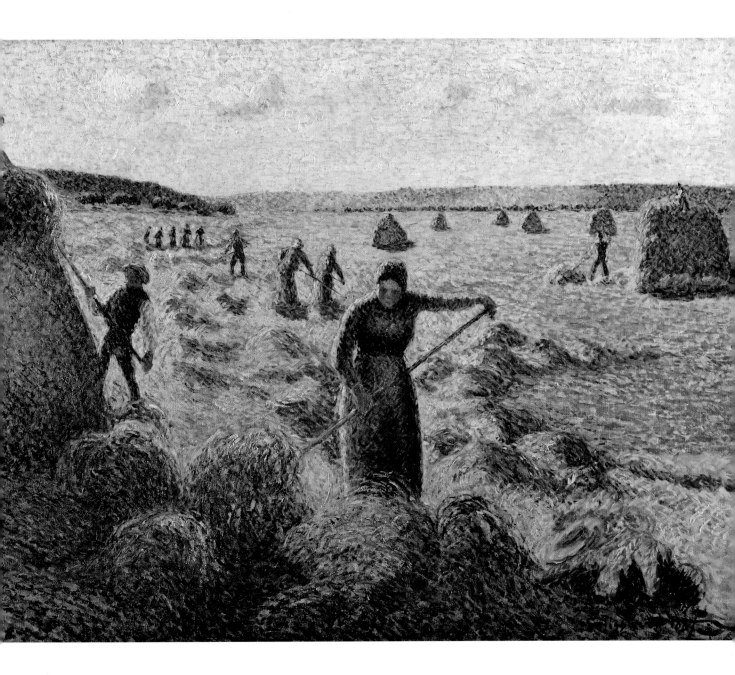

Camille Pissarro (1830–1903)
Oil on canvas, 51 x 66 cm (20 x 26 in) • Private Collection

Harvesting Hay, Éragny, *c.* 1887 After 1885, Pissarro adopted certain Neo-Impressionist techniques in his own work, most notably shown here in the juxtaposition of complementary colours to enhance the overall vividness and luminosity of the image.

Claude Monet (1840–1926)
Oil on canvas, 60 x 100 cm (23²/₃ x 39¹/₃ in) • Musée d'Orsay, Paris

Haystacks, End of the Summer, Morning Effect, 1891 For much of 1890, Monet worked continuously on the first of his series paintings on haystacks and poplar trees, exploring the effects of sun on the same motif at different times of the day.

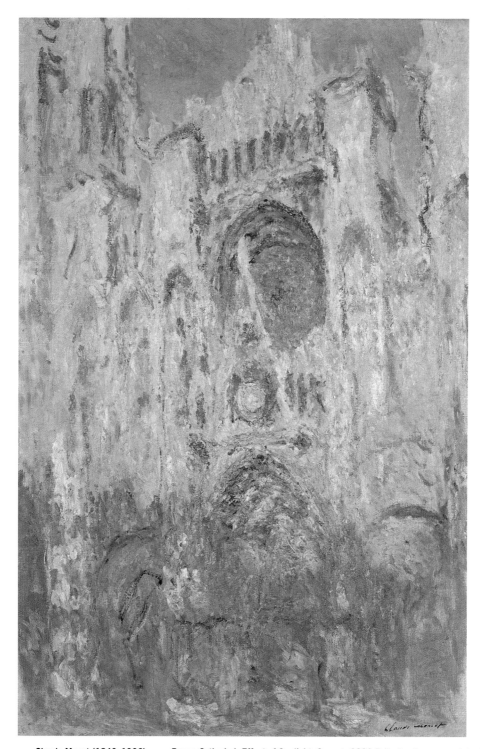

Claude Monet (1840–1926)
Oil on canvas, 100 x 65 cm (39^1/$_3$ x 25^1/$_2$ in) • Musée Marmottan
Monet, Paris

Rouen Cathedral, Effect of Sunlight, Sunset, 1892 Following the successful exhibition of his 'Haystacks' series at Durand-Ruel's gallery in 1891, Monet began a similar series, this time exploring of the effects of changing light on the same building, Rouen Cathedral.

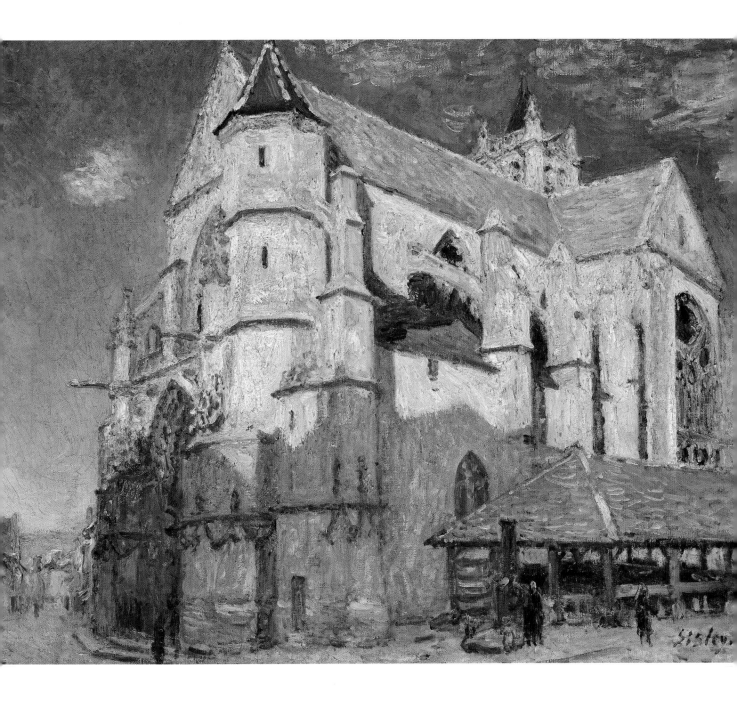

Alfred Sisley (1839–99)
Oil on canvas, 50 x 61.5 cm (19²/₃ x 24¹/₄ in) • Musée des
Beaux-Arts, Rouen

Church in Moret, Frosty Weather, 1893 Rather as Monet had done with his 'Rouen' series,
Sisley executed a number of paintings of the church at Moret at different times of the day,
and also in different seasons, to see the effect of the changing light.

Pierre-Auguste Renoir (1841–1919)
Oil on canvas, 65 x 81 cm (25^1/$_2$ x 32 in) • Fine Arts Museum of
San Francisco

Landscape at Beaulieu, *c.* **1893** From 1893 on, Renoir sought the warmer climate of the South of France due to the debilitating effects of rheumatoid arthritis. At first, he would spend only the winters there, but he eventually moved there permanently.

Armand Guillaumin (1841–1927)
Oil on canvas, 50 x 61 cm (19²/₃ x 24 in) • Private Collection

The Coast from L'Esterel, *c.* **1902** This painting anticipates the Fauvism of Henri Matisse and André Derain from about 1905. Close to Cannes on the French Mediterranean, L'Esterel was popular with artists at this time.

Claude Monet (1840–1926)
Oil on canvas, 89.5 x 100 cm (35¼ x 39⅓ in) • Musée d'Orsay, Paris

Waterlily Pond: Pink Harmony, 1900 Having bought a house at Giverny in 1890, Monet set about designing its substantial gardens around a large lily pond, providing him with a motif that would last until his death. Two Japanese bridges completed the scene.

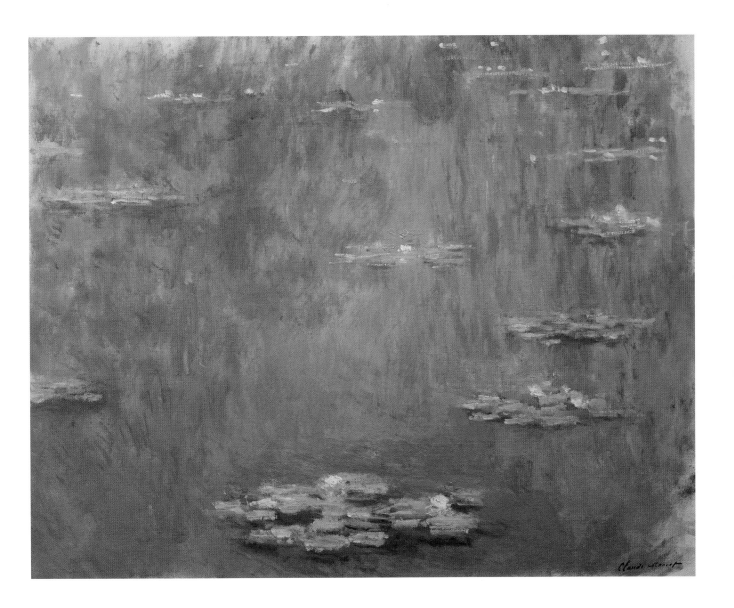

Claude Monet (1840–1926)
Oil on canvas, 73 x 92 cm (28³/₄ x 36¹/₄ in) • Musée Marmottan
Monet, Paris

Waterlillies, 1903 A number of artists began flocking to the village of Giverny to spend the summers close to Monet's house. The group, mostly from America, became known as the 'Decorative Impressionists'.

Claude Monet (1840–1926)
Oil on canvas, 82 x 92 cm (32¼ x 36¼ in) • Pushkin Museum, Moscow

Seagulls over the Houses of Parliament, 1904 Monet made several trips to London in his career, the last being in 1900. He was fascinated by its thick fogs, which created silhouettes of the buildings along the banks of the River Thames.

Claude Monet (1840–1926)
Oil on canvas, 65.2 x 92.4 cm (25²/₃ x 36¹/₃ in) • National Museum
of Wales, Cardiff

San Giorgio Maggiore by Twilight, 1908 Monet spent the autumn of 1908 in Venice with his
wife Alice. By this time, he was aware of his deteriorating eyesight due to cataracts, which was
eventually corrected by surgery.

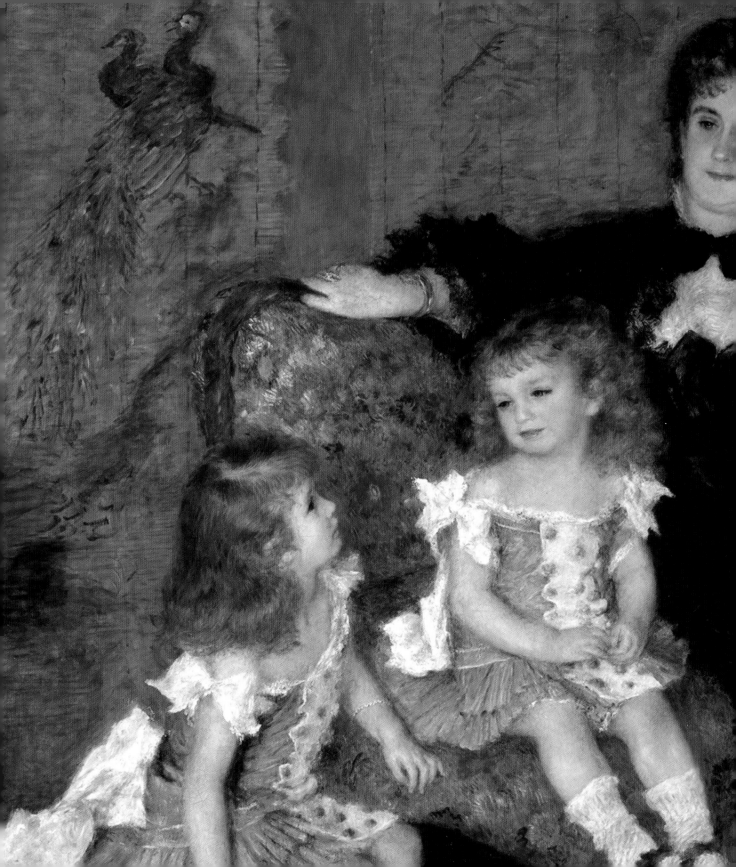

Domesticity

Although a subject predominantly the domain of women and women artists, certain aspects of domestic life were handled equally well by their male contemporaries.

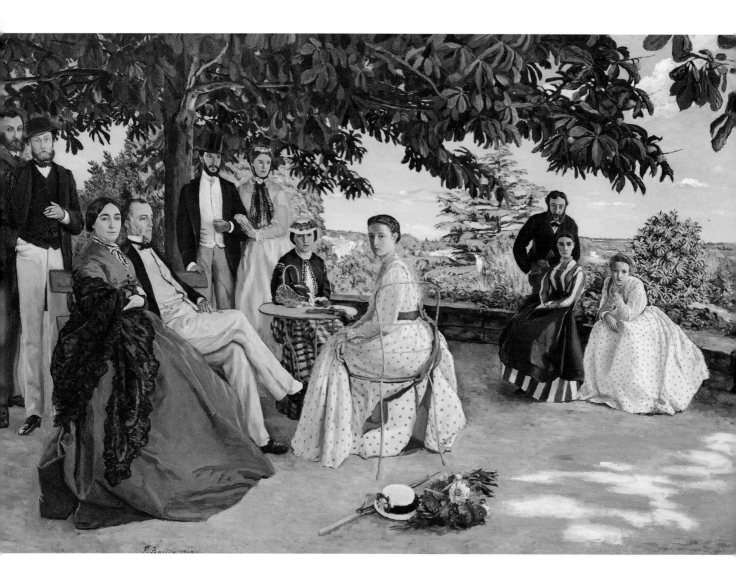

Frédéric Bazille (1841–70)
Oil on canvas, 152 x 230 cm (59⁴/₅ x 90¹/₂ in) • Musée d'Orsay, Paris

Family Reunion, 1867 This painting was shown at the Salon of 1868, and depicts members of Bazille's own extended haute bourgeois family, in the grounds of his father's large house in Montpelier.

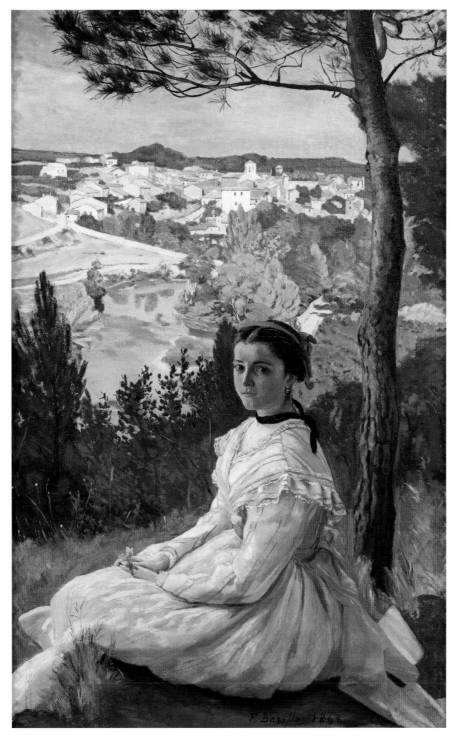

Frédéric Bazille (1841–70)
Oil on canvas, 130 x 89 cm (51 x 35 in) • Musée Fabre, Montpelier

View of the Village, Castelnau, 1868 From his father's estate at Méric, Bazille painted this view down to the village of Castelnau-sur-Lez, which is bathed in an intense sunlight. It was shown at the Salon of 1869.

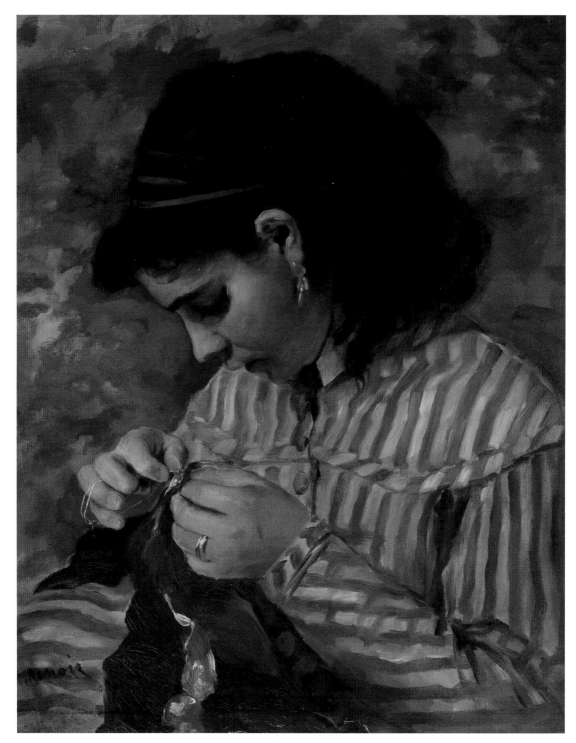

Pierre-Auguste Renoir (1841–1919)
Oil on canvas, 55.9 x 45.7 cm (22 x 18 in) • Dallas Museum of Art

Lise Sewing, *c.* 1867–68 Lise Tréhot posed for at least a dozen of Renoir's early paintings and was most probably his mistress at the time. She stopped modelling for him in 1872 when she got married.

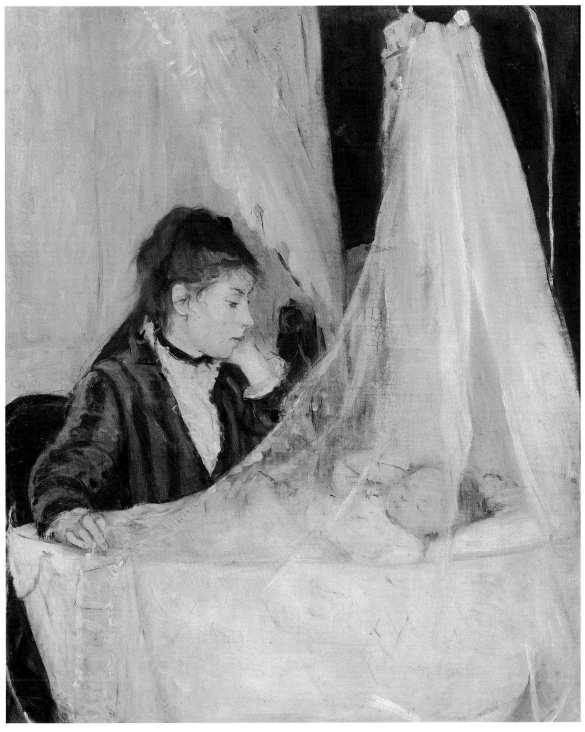

Berthe Morisot (1841–95)
Oil on canvas, 56 x 46 cm (22 x 18 in) • Musée d'Orsay, Paris

The Cradle, 1872 One of Morisot's best-known paintings, it depicts her sister Edma beside the cradle of her daughter. It is one of many mother-and-child images the artist painted in her career.

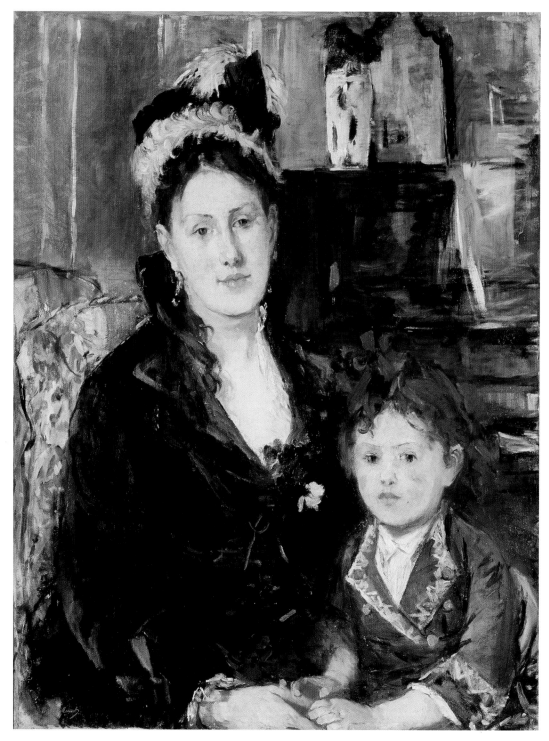

Berthe Morisot (1841–95)
Oil on canvas, 73 x 56.5 cm (28³/₄ x 22¹/₄ in) • Brooklyn Museum
of Art, New York

Portrait of Mme Boursier and Her Daughter, 1873 Madame Boursier was the artist's cousin and is depicted here with her daughter. The viewer is invited into this intimate space by the artist through her clever composition of the sitters at close proximity.

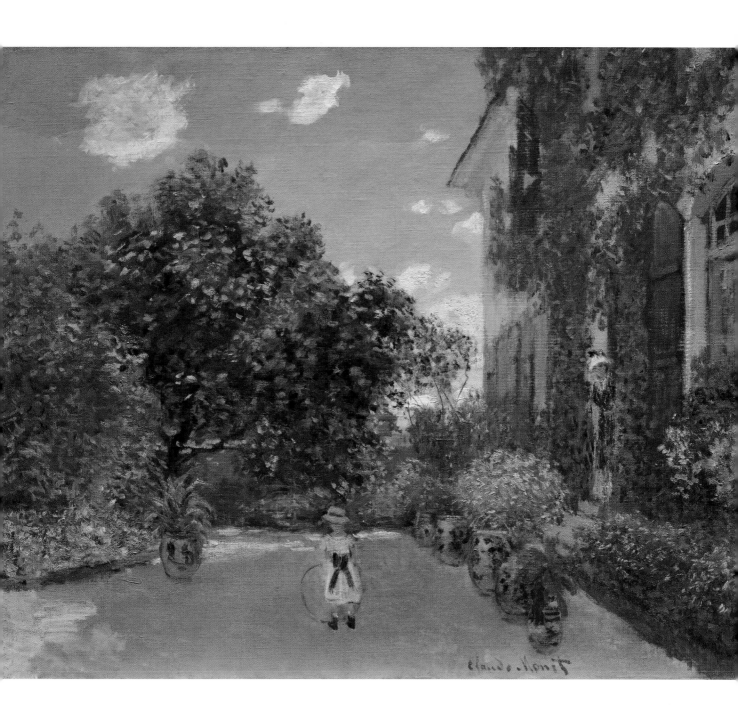

Claude Monet (1840–1926)
Oil on canvas, 60.2 x 73.3 cm (23³/₄ x 28³/₄ in) • The Art Institute
of Chicago

The Artist's House at Argenteuil, 1873 Between 1871 and 1875, Monet lived in this house with his first wife Camille, whom he married in 1870. She had already given birth to their first son Jean in 1867.

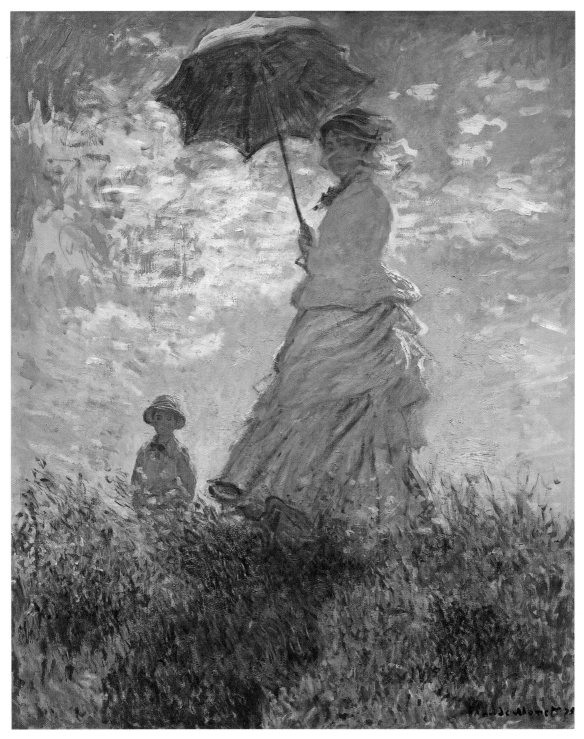

Claude Monet (1840–1926)
Oil on canvas, 100 x 81 cm (39$\frac{1}{3}$ x 32 in) • National Gallery of Art, Washington, DC

Woman with a Parasol – Madame Monet and Her Son, 1875 This carefree painting of his family belies the extreme poverty that Monet was experiencing at this time due to the downturn of the French economy and the disastrous first Impressionist exhibition.

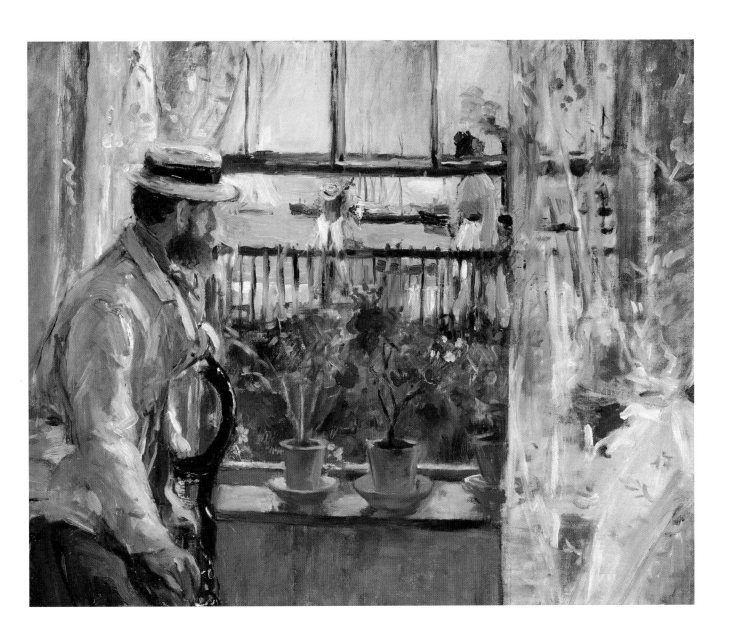

Berthe Morisot (1841–95)
Oil on canvas, 36 x 46 cm (14 x 18 in) • Musée Marmottan Monet, Paris

Eugène Manet on the Isle of Wight, 1875 Morisot visited the Isle of Wight in the summer of 1875, with her new husband Eugène Manet. This painting is an extraordinary tour de force of Impressionist painting, much admired by her brother-in-law, Édouard Manet.

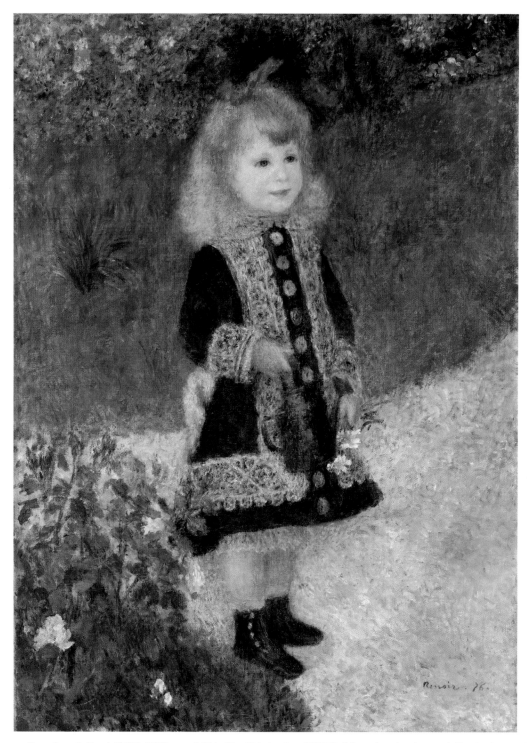

Pierre-Auguste Renoir (1841–1919)
Oil on canvas, 100 x 73 cm (39$\frac{1}{3}$ x 28$\frac{3}{4}$ in) • National Gallery of Art,
Washington, DC

A Girl with a Watering Can, 1876 Of all the male artists, it was only Renoir who was able to apply the delicate touches to the facial features of his sitters without betraying his Impressionist principles. This painting is exemplary.

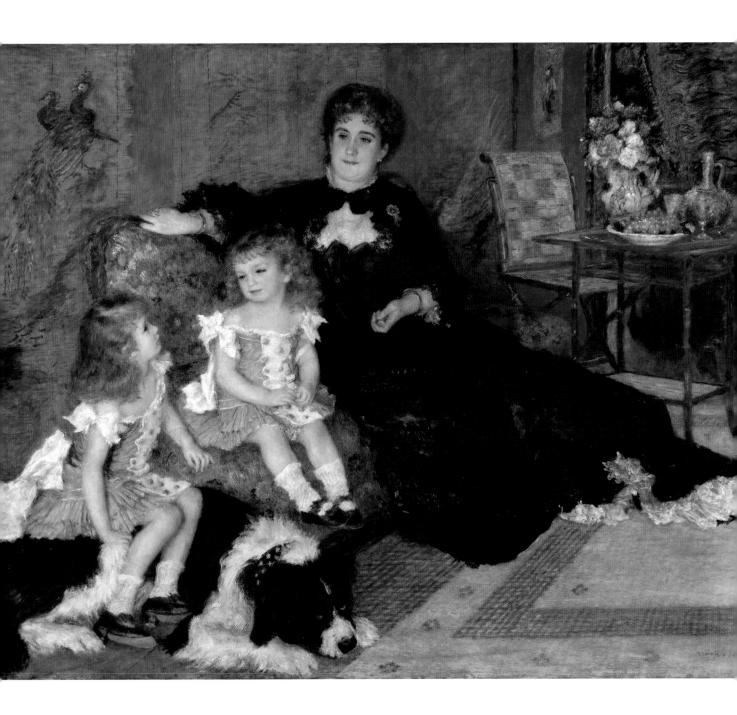

Pierre-Auguste Renoir (1841–1919)
Oil on canvas, 153.7 x 190.2 cm (60¹/₂ x 74⁷/₈ in) • Metropolitan
Museum of Art, New York

Madame Georges Charpentier and Her Children, 1878 In the years after the collapse of the French
economy in the mid-1870s, Renoir came to rely on society portraiture of the bourgeoisie. Madame
Charpentier was married to the publisher of Emile Zola's novels.

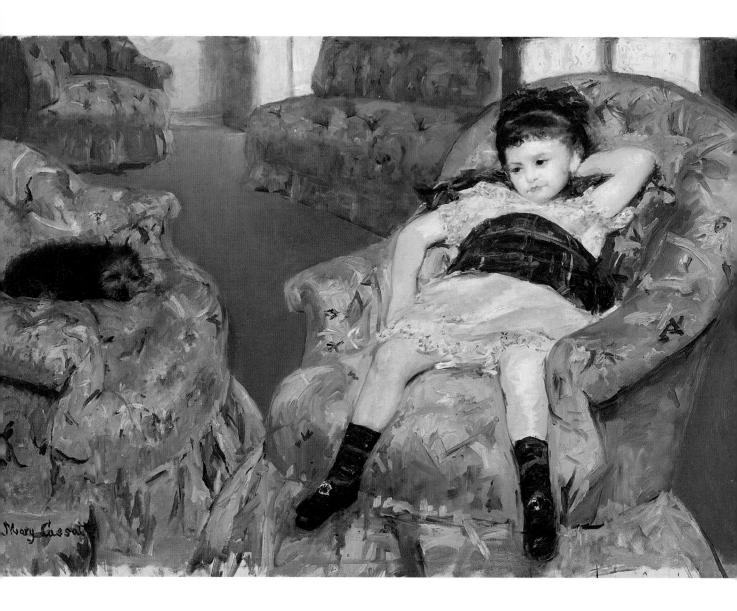

Mary Cassatt (1844–1926)
Oil on canvas, 89.5 x 129.8 cm (35¼ x 51 in) • National Gallery of Art, Washington, DC

Little Girl in a Blue Armchair, 1878 This picture is an intriguing image of awkwardness in a child too young to understand correct deportment. This is made all the more obvious by the artist, who has placed her in an overlarge chair.

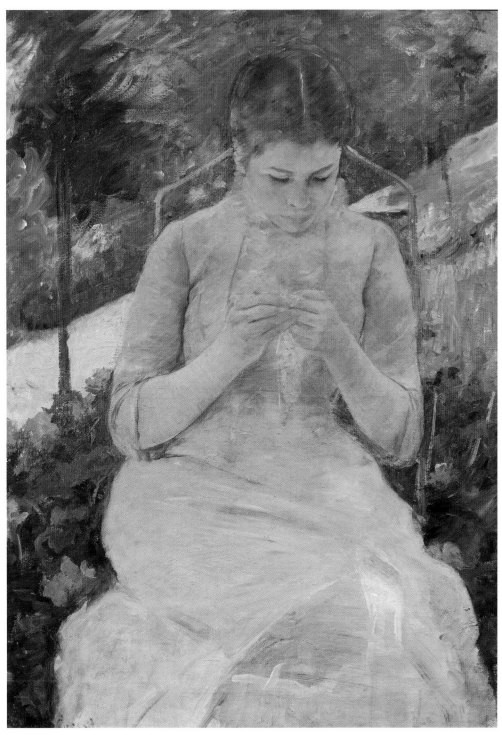

Mary Cassatt (1844–1926)
Oil on canvas, 92 x 63 cm (36¹/₄ x 24⁴/₅ in) • Musée d'Orsay, Paris

Girl in the Garden (or Woman Sewing), *c.* **1880–82** This painting was shown at the eighth and final Impressionist exhibition in 1886. This domestic image is one of many that Cassatt painted of women and children shown in the privacy of daily life.

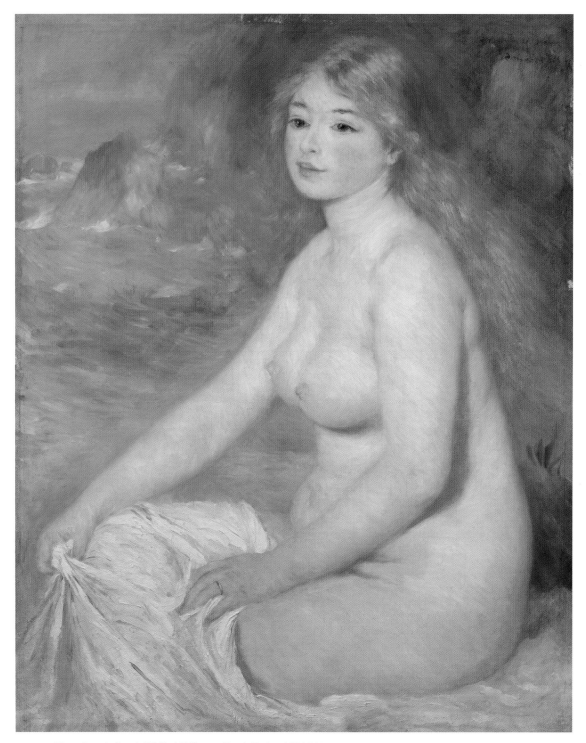

Pierre-Auguste Renoir (1841–1919)
Oil on canvas, 81.6 x 65.4 cm (32 x 25³/₄ in) • Sterling and Francine
Clark Art Institute, Williamstown

Blonde Bather, 1881 While on the cusp of moving away from Impressionism, Renoir travelled to Italy in the autumn of 1881 to study the Renaissance masters. This painting is clearly influenced by Raphael.

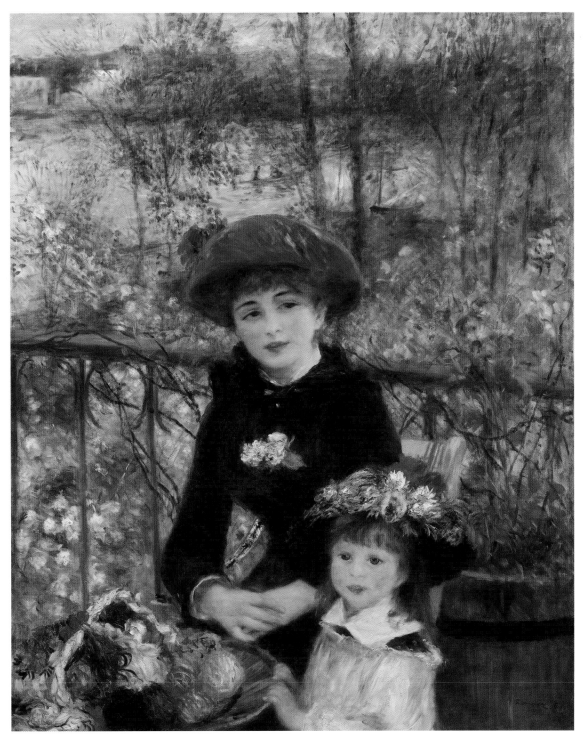

Pierre-Auguste Renoir (1841–1919)
Oil on canvas, 100.4 x 80.9 cm (39^1/$_2$ x 31^4/$_5$ in) • The Art Institute
of Chicago

Two Sisters (On the Terrace), 1881 The two sitters in this painting are in fact not related, the title of the work being given by Durand-Ruel when he purchased the painting directly from the artist's studio.

Berthe Morisot (1841–95)
Oil on canvas, 50.6 x 42.2 cm (20 x 16½ in) • Private Collection

Child in the Hollyhocks, 1881 A work of pure Impressionism in which the viewer catches this moment in the blinking of an eye. The location and the little girl are blurred, such is the transience of the scene.

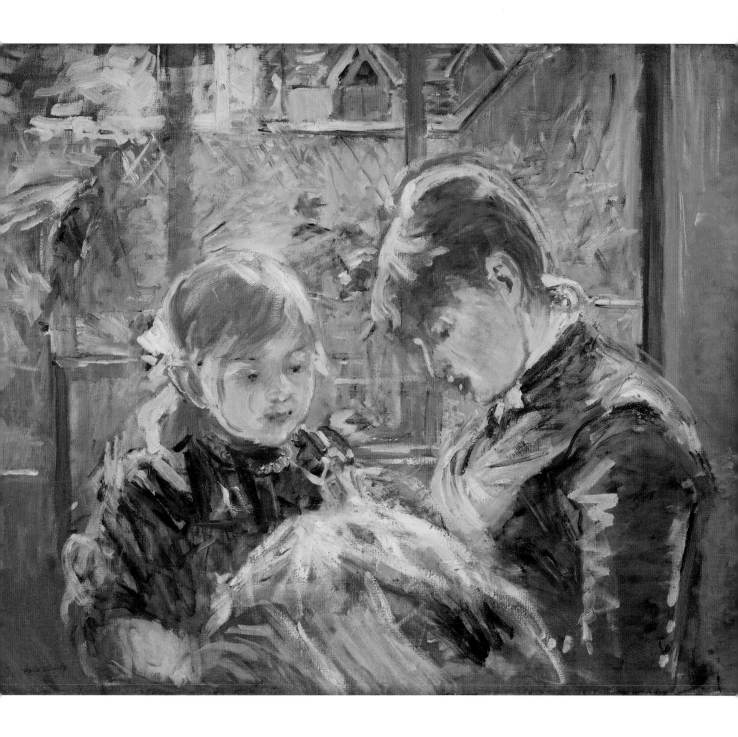

Berthe Morisot (1841–95)
Oil on canvas, 57.2 x 71.1 cm (22¹/₂ x 28 in) • Minneapolis
Institute of Arts

The Artist's Daughter Julie with Her Nanny, *c.* 1884 Morisot's only child Julie is depicted here with her nanny, customary domestic help for haute bourgeois families at this time. Morisot died when Julie was only sixteen years of age.

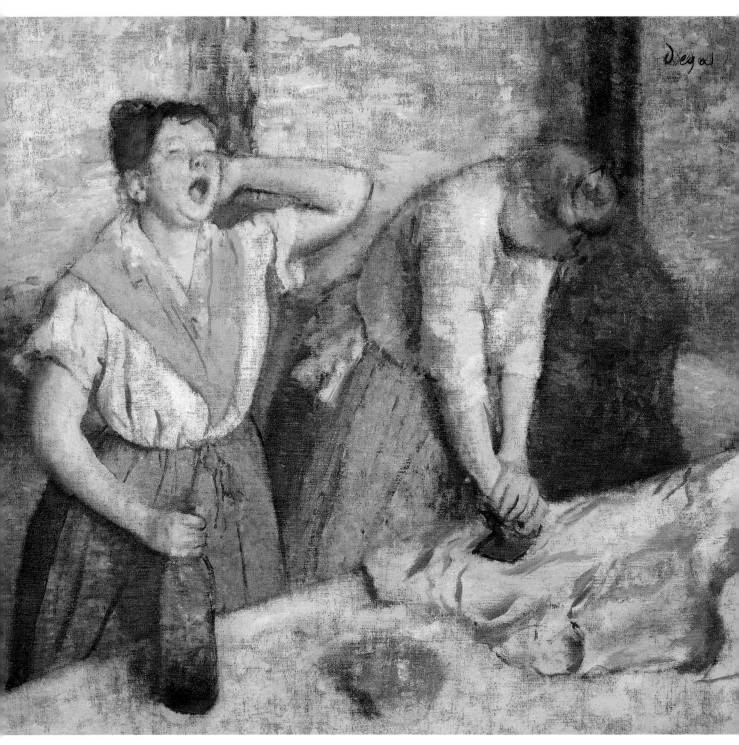

Edgar Degas (1834–1917)
Oil on canvas, 76 x 81.5 cm (30 x 32 in) • Musée d'Orsay, Paris

The Laundresses, *c.* 1884 This painting is also known as *Women Ironing* and is one of a series of paintings that the artist executed portraying the harsh working conditions of women in Paris. The same theme was explored in some of Zola's novels.

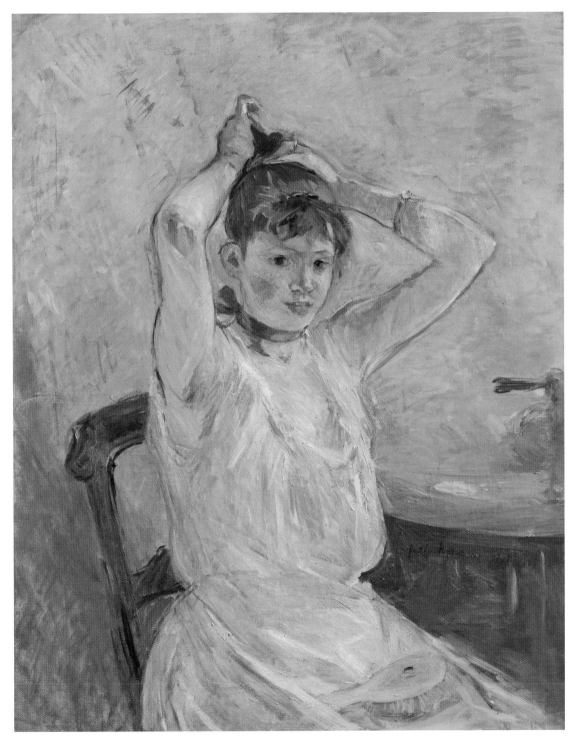

Berthe Morisot (1841–95)
Oil on canvas, 91.1 x 73.3 cm (35⁴/₅ x 28⁴/₅ in) • Sterling and Francine
Clark Art Institute, Williamstown

The Bath (Girl Arranging Her Hair), 1885–86 At the time of the artist's death, this painting was unsold and was acquired by her friend Claude Monet. It had been exhibited at the final Impressionist exhibition in 1886.

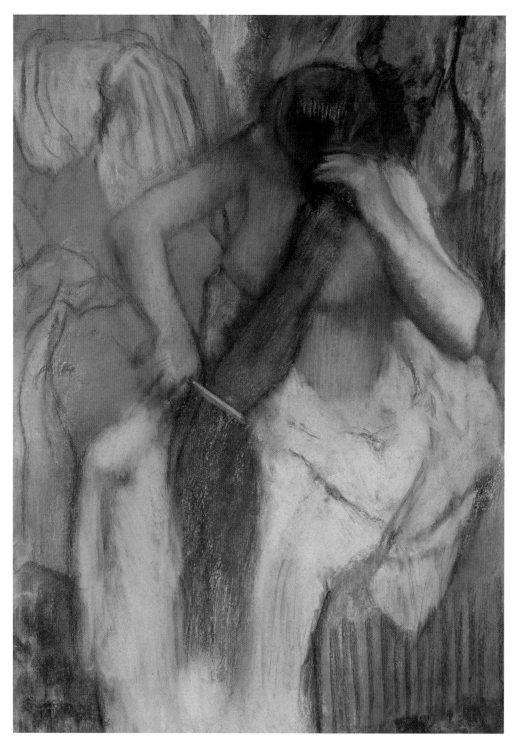

Edgar Degas (1834–1917) **La Toilette (Woman Combing Her Hair), 1887–90** There is often a sense of voyeurism with many of
Pastel on paper, 82 x 57 cm (32¼ x 22⅖ in) • Musée d'Orsay, Paris these intimate scenes depicted by Degas. It is as though the bather is unaware of the artist's presence.

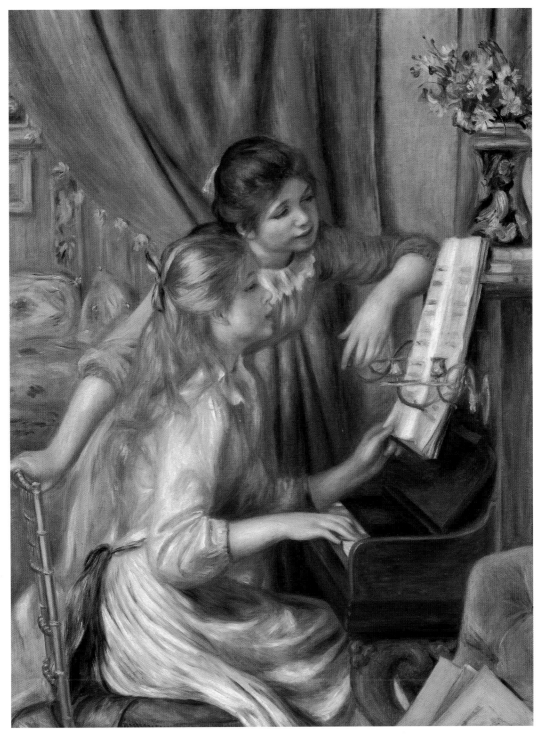

Pierre-Auguste Renoir (1841–1919)
Oil on canvas, 116 x 90 cm (45²/₃ x 35²/₅ in) • Musée d'Orsay, Paris

Young Girls at the Piano, 1892 Following on from his 'dry period' in 1888, Renoir reverted to a form of Impressionism that was more fully formulated. This can be seen in his figure paintings of young women, their faces more radiantly portrayed.

Berthe Morisot (1841–95)
Oil on canvas, 63 x 114 cm (24⁴/₅ x 44⁴/₅ in) • Musée Marmottan
Monet, Paris

Shepherdess Resting, 1891 The artist was one of Renoir's closest friends, this image being especially redolent of his oeuvre. Morisot held Thursday dinners, to which Renoir and others such as the writer Stéphane Mallarmé were regularly invited.

Indexes

General Index

Masterpieces of Art
FLAME TREE PUBLISHING

A new series of carefully curated print and digital books covering the world's greatest art, artists and art movements.